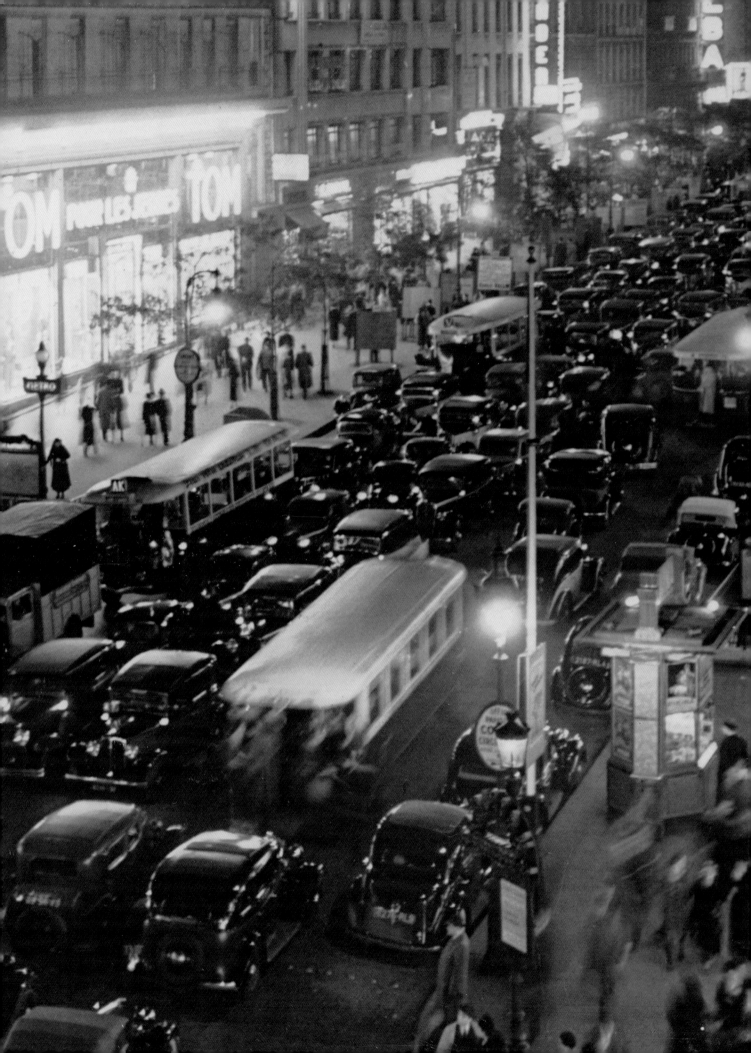

MODERNIST PHOTOGRAPHY

Selections from the Daniel Cowin Collection

edited by Christopher Phillips and Vanessa Rocco

ICP / STEIDL

Published in conjunction with the exhibition *Modernist Photography: Selections from the Daniel Cowin Collection* organized by the International Center of Photography.

Exhibition Dates: September 16 through November 27, 2005.

This exhibition was made possible through the generosity of Mrs. Daniel Cowin.

First edition 2005

Copublished by the International Center of Photography, New York, and Steidl Publishers, Göttingen, Germany
© 2005 for this edition: International Center of Photography, New York

Director of Publications: Karen Hansgen
Editors: Christopher Phillips and Vanessa Rocco
Copyeditor: Deborah Drier
Design: Claas Möller / Steidl Design
Separations: Steidl's digital darkroom
Production: Steidl, Göttingen

International Center of Photography

1114 Avenue of the Americas
New York, NY 10036
www.icp.org

STEiDL

Düstere Str. 4 / D–37073 Göttingen
Phone +49 551-49 60 60 / Fax +49 551-49 60 649
E-mail: mail@steidl.de
www.steidl.de
www.steidlville.com

ISBN 3–86521–158–5
(ISBN 13: 978-3-86521-158-3)
Printed in Germany

cover: Henryk Hermanowicz, *Woman with Closed Eyes*, 1937 (detail).
frontispiece p. 2: Brassaï, *Street Scene, Paris*, ca. 1930s (detail).
frontispiece p. 10: Unidentified artist, *Douglas Fairbanks Film Premiere, Grauman's Chinese Theater, Hollywood*, 1928-29 (detail).
frontispiece p. 42: Dorothea Lange, *Hoe culture. Tenant farmer near Anniston, Alabama*, 1936 (detail).
frontispiece p. 66: Carl Strüwe, *Straight Lines: Crystal of Coffea Arabica*, n.d. (detail).
frontispiece p. 90: Werner Rohde, *Pit and Renata*, ca. 1933 (detail).

CONTENTS

DIRECTOR'S FOREWORD AND ACKNOWLEDGMENTS

This exhibition, *Modernist Photography: Selections from the Daniel Cowin Collection*, marks an effort to honor the legacy and vision of our former trustee and friend Daniel Cowin. Daniel's involvement with the International Center of Photography began in 1983. He joined the ICP Board of Trustees in 1987 and served as an active board member until his death in 1992. A banker by profession, he was also a passionate and tireless collector, whose interests ranged from folk art to Renaissance furniture to nineteenth-century American painting. His adventurous approach was especially evident in his collecting of photography, where he often proved far ahead of his time.

Daniel was drawn to subjects and photographers that he felt to be overlooked and undervalued. He assembled, for example, a remarkable collection of more than 3,000 photographs documenting African-American life from the mid-nineteenth century to the 1950s, which he generously donated to ICP in 1990. He was intuitively attracted to the avant-garde photography of the 1920s and '30s, and acquired works by such pioneers as Man Ray, Berenice Abbott, and Walker Evans. But he took particular delight in discovering visually innovative works by important but unrecognized photographers from such countries as Spain, Poland, and Czechoslovakia before they came to the attention of museum curators or other collectors. Many of these works were featured in a 1997 ICP exhibition, *Images of the Machine Age: Selections from the Daniel Cowin Collection*.

Modernist Photography: Selections from the Daniel Cowin Collection presents sixty-six works chosen by ICP curators from the more than 1,200 modernist-era photographs in the Daniel Cowin collection. For their generosity in making this exhibition possible, I wish to extend my deepest thanks to Joyce Cowin, who has devoted herself to maintaining and preserving her husband's collections, and to their children, Kenneth, Andrew, and particularly Dana Cowin.

Many individuals deserve acknowledgment for their work in bringing this exhibition and publication to completion, in particular Curator Christopher Phillips and Assistant Curator Vanessa Rocco for organizing and overseeing this project. Also in the ICP Exhibitions Department, special thanks to Brian Wallis, Director of Exhibitions and Chief Curator; Assistant Curator Kristen Lubben and Research Assistant Annie Bourneuf who also contributed texts for this book; Assistant Curator Cynthia Young; Registrar Barbara Woytowicz; Production Manager Robert Hubany; and Preparator Karlos Carcamo. I am grateful to Director of Publications Karen Hansgen for the careful attention that she directed to this publication, to Deborah Drier and Managing Editor Jeffrey Tompkins for their editorial assistance, and to Gerhard Steidl, our publications partner, designer Claas Möller, and the entire staff at Steidl for such a beautiful book. Thanks also to those who carried out invaluable research on individual photographers in the Daniel Cowin Collection, interns Emily Bierman, Mónica Núñez Laiseca, and Maren Ullrich. Special thanks to Frank B. Arisman and Andrew E. Lewin for their continued support of our publications program.

Willis E. Hartshorn / Ehrenkranz Director

INTRODUCTION

The years between the two World Wars witnessed a burst of extraordinary innovation in visual culture, nowhere more so than in the realm of photography. Enthusiasm for the advent of an urban, technological civilization reached a peak during this period, and by the late 1920s a host of inventive young photographers—often allied with such avant-garde movements as Constructivism, the Bauhaus, and the New Objectivity—had created an image of the metropolis that identified the skyscraper city with dynamism and glittering prosperity. By the early 1930s, however, this euphoric image was shattered as an economic crisis of unprecedented scope swept Europe and America. Again, it was photographic images, this time by young documentary photographers and photojournalists, that captured the desperate efforts to revive urban and rural communities during the remainder of the decade.

The photographs in the Daniel Cowin Collection provide a remarkably accurate sample of the varied roles that photography played during this era: symbol of the technological fervor of the Machine Age, medium of avant-garde artistic experiment, vehicle for the seductions of mass advertising, and documentary tool for registering social reality. The essays in this volume explore these roles through close consideration of a number of works from the Daniel Cowin Collection. In the course of illuminating individual images, the authors provide an introduction to the riches and complexities of a remarkable period.

The general artistic fascination with technology during the early 1920s can be gleaned from the titles of articles that appeared in European avant-garde journals of the day: "The Beauty of the Machine," "On the Form of the Automobile," "The Aesthetics of Film", "The City of the Future," "Mechanization of the Arts."[1] The aesthetic stimulation furnished by technological devices is notably evident in the pages of László Moholy-Nagy and Lajos Kassak's *Book of New Artists* (1922), where reproductions of modernist artworks are juxtaposed with photographs of high-tension wire towers, movie projectors, racing cars, dynamos, Manhattan skyscrapers, power drills, airplanes, and electric clocks. Moholy, a prominent teacher at the Bauhaus, was among the first to propose that photography itself should be understood as an integral part of the new technological era. In his enormously influential 1925 book *Malerei Photographie Film* (Painting Photography Film), he hailed the camera as a "new instrument of vision": a technological extension of the eye whose images promised precision, objectivity, economy, and repeatability. Regarding photography as the new "standard language" of visual communication, Moholy advanced a range of experimental procedures meant to enhance the medium's suppleness and flexibility. These included not only the use of extreme and unaccustomed camera viewpoints but extended to the use of photograms, stop-action photography, time exposures, negative imagery, microscopic photography, and photomontage.[2]

Among these experimental means, photomontage became one of the characteristic visual forms of the 1920s-'30s, practiced by Berlin Dadaists, Russian Constructivists, Bauhaus artists, and Surrealists

alike. Involving the combination of preexisting photographic images and typography, photomontage yields works of startling visual complexity. Even in the 1920s it was recognized that the fractured, mosaic space of montage–and the abrupt shifts of scale, time, and mood that it made possible–represented a dramatic break with the centuries-old tradition of unified perspective. In a particularly provocative way, montage registered the fact that the chaotic daily realities of the early twentieth century had burst the traditional frame of experience.[3]

The unconventional approaches to photography, typography, and graphic design encouraged by Moholy and his avant-garde colleagues did not escape the attention of the nascent advertising industry. As early as 1924, American advertising professionals concluded that experimental photographic images could be enormously effective in commercial illustration. In that year, the US trade journal *Printer's Ink* informed its readers, "Hitherto, illustrations strove for the normal viewpoint. The new idea is to show the advertised subject from an unusual but entirely possible point of view. This point of view is determined, not by whim, but by experiment, and represents that point of view from which the subject can 'sell' itself to best advantage."[4] The same journal later assured commercial art directors that "the camera can be made to do almost anything. It need remain nowhere near as intensely literal and true-to-life as the average person might be led to believe."[5]

By the late 1920s, a seemingly paradoxical situation was evident in both the US and Europe: avant-garde artists with socialist sympathies were enthusiastically soliciting advertising assignments from capitalist enterprises. The surprisingly benign view of commercial advertising held by many avant-gardists grew directly out of the "machine romanticism" of the early 1920s. All people have the same basic needs for food, housing, and clothing, it was argued, and these needs could best be satisfied by mass-produced products of simple, standard design. Seen in this light, industry–even capitalist industry–appeared as a vital modernizing force, whose productive capacities would be developed still further when socialism inevitably triumphed. To counter popular resistance to standardized, machine-made goods, many avant-gardists embraced advertising as a valuable means to "modernize" public taste. By the early 1930s, of course, the situation had changed. With the onset of a worldwide economic depression and the temporary eclipse of the new consumer capitalism, it now required considerable ingenuity to hold to this optimistic position.

The Great Depression and the accompanying political turmoil of the 1930s gave new prominence to what were described at the time as the "fact genres": photojournalism, documentary film and photography, newsreels, and written reportage. All of these genres brought a sense of irrefutable, eyewitness immediacy to the reporting of contemporary events, while at the same time subtly suggesting to their audience how these events should be understood. The triumph of the fact genres instilled a palpable fear among traditional intellectuals. In 1932, at the height of the craze for photographic reportage in German illustrated magazines, the writer Ludwig Marcuse complained that the new communications media were depriving the intellectual of his role of interpreting the world to the public at large. That role, he sighed, was more and more being taken over by the journalist, the newsreel cameraman, and the photographer.[6]

That the documentary approach of the 1930s turned on the interpretation of facts as much as their recording was one of the chief lessons of the celebrated photographic section of the Farm Securi-

ty Administration, an agency of the Roosevelt New Deal. The primary impetus behind the FSA project was the need for photographic material that could be used to rally public support for Roosevelt's controversial plan to aid the rural poor. The most frequently reproduced images from the Farm Security Administration's photographic section vividly evoke the grimness of the Depression era–a time when nearly one-quarter of American workers were jobless, and when foreclosure and drought forced tens of thousands of farmers and rural workers off the land.

The head of the FSA's photography section, Roy Stryker, nevertheless entertained a far more ambitious vision of the group's mission than either documenting evidence of suffering or insisting on the dignity of the nation's poor. His true interest in photography, he maintained, lay in its use in the recording and interpretation of complex environments in series of images. The FSA project, as Stryker imagined it, aimed at nothing less than the creation of an archive that would provide a panoramic picture of everyday life in America. For the FSA photographers, such a broad mandate left considerable room for the play of individual approaches and for the exploration of countless themes. The formal, frontal view-camera work of Walker Evans, for example, was perfectly suited to depicting the vernacular American architecture that was his preferred subject. Dorothea Lange, on the other hand, specialized in intensely realized photographic encounters with individuals, often migrant farmers or the dispossessed; and Russell Lee exploited advances in flash technology to record in minute detail the interiors of humble dwellings. The more than 100,000 selected prints that were captioned, filed, and indexed in the FSA picture archive between 1935 and 1943 reveal that within the documentary style of the period there existed unexpected latitude for individual, interpretive camera work.

Whether they employ the techniques of documentary realism or those of hyperbolic fantasy, the photographs of the 1920s and 1930s display a confidence and audacity that has seldom been equaled in the decades that have followed. Many cultural historians today look with skepticism on the avant-gardist claim that artistic experiment can prefigure a wider social transformation, and the intervening years have doubtless thrown into sharp relief the contradictions that ultimately undermined avant-garde ideals. Nevertheless, the works in the Daniel Cowin Collection still confront us with the astonishing power that can be released when imagination and reality collide.

Christopher Phillips

1 These titles are taken from articles that appeared in the German journals *Das Kunstblatt* and *Die Form*.
2 See László Moholy-Nagy, *Painting Photography Film* (Cambridge, MA: MIT Press, 1969).
3 See Matthew Teitelbaum, ed., *Montage and Modern Life 1919-1942* (Cambridge, MA: MIT Press, 1992).
4 W. Livingston Larned, "Making Novel Perspective the Pictorial Keynote of the Campaign," *Printer's Ink*, January 10, 1924, 33.
5 Larned, "The Advertising Camera Goes for Extraordinary New Devices," *Printer's Ink*, August 18, 1927, 158.
6 Ludwig Marcuse, "Produzieren wir noch Legende?" *Das Tagebuch*, vol. 13, no. 19, 1932, 727.

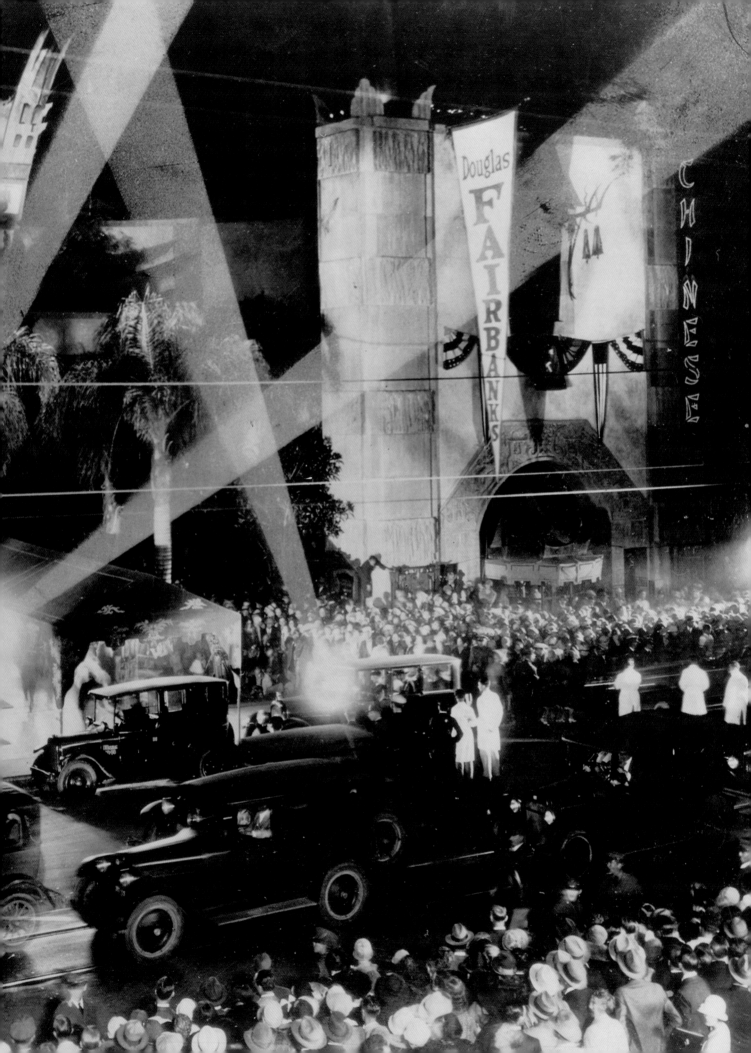

THE PHOTOGRAPHER IN THE CITY

By Christopher Phillips

The wave of urbanization and industrialization that swept through Europe and America during the nineteenth century brought into being an unprecedented type of urban space–densely populated, dominated by impersonal technological processes, and animated by the constantly accelerating tempo of all activities. Just how to understand the new metropolis and how to come to terms with the dawning Machine Age were questions that occupied countless architects, writers, artists, and photographers during the early decades of the twentieth century.

If enthusiasm for the promises of big-city life reached a fever pitch in the 1920s, it was the camera media of photography and cinema that conveyed the most compelling and seductive vision of the metropolis. The camera did not simply mirror the existing state of cities like New York, Paris, Berlin, or Moscow, which in reality were often still weighed down by the social and architectural legacies of the past; instead, it selectively highlighted the most dramatic elements of the emerging urban order. As a result, the most memorable images of this period often furnish bold anticipatory glimpses of a "new world" that was in fact only beginning to take tangible form.[1]

Awareness that the new Machine Era would transform every corner of social life was stimulated by World War I. A series of photographs made during the course of the war by Harry Bedford Lemere at the Primrose Roadworks in Liverpool, England, demonstrates one aspect of the changes that were underway. Lemere and his father were professional photographers, based in London, whose firm enjoyed a reputation for high achievement in architectural and industrial photography.[2] One of their regular clients, the Cunard shipping line, had used the Liverpool factory as an engineering center in peacetime, but during the war it was turned into a munitions factory for manufacturing artillery shells and other war-related products. Lemere's photographs show an industrial interior filled with identically dressed women war workers operating large, complicated machines. If these images remind us of the rationalization of factory labor that was required for the production of standardized industrial products, they also point to the war-induced abandonment of the old divisions that had traditionally separated women's work from that of men. Lemere's images are remarkable for their controlled composition and for the air of seriousness and concentration that emanates from the women workers. They furnish a striking counterpart to the well-known paintings (now in the Imperial War Museum in London) of female munitions workers that were commissioned

by the British Ministry of Information and carried out by Anna Airy at the Singer Manufacturing Company in Glasgow.

World War I confirmed the ascendancy of a powerful new culture based on technological processes and products. In the years immediately following the war's end, photography was increasingly seen to embody the same principles that were at the heart of the emerging technological world: economy, precision, objectivity, standardization, and repeatability. Even though the medium was almost 100 years old, it was suddenly understood to belong to that group of technical discoveries that were irrevocably altering the human world and human consciousness. Photography thus became, for younger visual artists, a medium of passionate interest and intensive experiment.

The Berlin Dada artist Raoul Hausmann, for example, insisted that photography offered a way to meet the new perceptual challenges of urban space. He wrote enthusiastically of the "schooling of the eye through the mechanical optic" and hailed the camera as a tool for mastering the new visual demands posed by the city. "Today," he wrote, "through the railway, the airplane, the photographic apparatus and the Roentgen ray, we have acquired such a power of discrimination that, thanks to the mechanical augmentation of our natural potentials, a new kind of optical knowledge has become possible."[3] In Hausmann's pioneering photomontage works of 1918-23, the city was presented as a place where older ways of life were continually fragmented and reconfigured in novel ways. Such images, characteristic of the Berlin Dada group to which Hausmann belonged, encouraged the viewer to imagine the city itself as a vast montage—an accumulation of discontinuous spaces, tempos, and lifestyles that never quite cohere in a graspable whole.

Building II (1927), a photomontage by the Polish artist Mieczslaw Berman, proceeds from very different assumptions. Berman, like the Russian Constructivist artists such as El Lissitzky who inspired him, felt that simplified geometric forms were the building blocks of a new Machine Age art–not just because of their abstract beauty, but also because they correspond to the geometric underpinnings of the new urban environment. This attitude, widespread during the 1920s, was given perhaps its most succinct form by the Dutch avant-garde painter Piet Mondrian. "The truly modern artist," he wrote, "regards the metropolis as an embodiment of abstract life; it is closer to him than nature, it will give him an emotion of beauty. For in the metropolis, nature has already been straightened out and regulated by the human spirit. . . ."[4]

Building II is a photomontage in which elongated rectangles of photographic imagery alternate with rectangular strips of colored paper. The photographs show construction workers at a building site perched precariously on metal beams that shoot into the air. Combining geometric graphic forms with realistic photographic images of workers, Berman reminds us that the coolly calculated designs of architects and engineers must always be realized by sheer physical human labor. The same theme is evident in Berman's photomontage *Armor for the Nation* (1938). In this work, the hunched-over figure of a toiling laborer provides a striking counterpoint to the upwardly thrusting diagonal forms that culminate in the summit of a skyscraper set against heroically billowing clouds.[5]

Photomontages like Berman's sought to distill a sense of order from the dizzying perceptual flow of the metropolis. Other artists used the camera to create images that effectively freeze the flux of the city, making possible a leisurely, detached contem-

plation of people, buildings, objects, and scenes that might otherwise go unperceived amid the bustle of urban life. Man Ray's understated *Empire State Building* (1936), for example, singles out a visual quality that figured prominently in the urban aesthetic of the early twentieth century–the accentuated verticality of the skyscraper. Thanks to the carefully selected vantage point, the viewer's eye is carried irresistibly upward as the Empire State Building rises majestically into the sky over Manhattan.

For many photographers during these years, the spectacle of the nighttime city, ablaze with the lights of high-rise buildings, flashing advertising signs, and automobile headlights, proved irresistible. Berenice Abbott's *New York at Night* (1934) is one of the most perfectly realized visions of the breathtaking splendor of the city night. Abbott went to considerable lengths to capture this image. She sought out the perfect sheltered vantage point and then obtained the landlord's permission to use it. She first calculated the time of day when the maximum number of office lights would be on (just before 5:00 p.m.) and waited until the shortest day of the year (December 20) to carry out a fifteen-minute exposure. The resulting image presents Manhattan as a fairyland, with the myriad lighted windows of midtown office towers creating dazzling geometric patterns that gradually reveal the presence of the buildings themselves.

Photographs of comparable nighttime scenes bear the special stamp of individual locales. Brassaï's *Street Scene, Paris* (ca. 1930s), for instance, depicts a spacious street of the French capital packed with gleaming automobiles and buses–a nocturnal traffic jam that leaves the city apparently devoid of pedestrians. An even more striking late-1920s image, this time by an unidentified photographer, presents the tumultuous scene in front of Grauman's Chinese Theater on the evening of a Hollywood film premiere. Beneath the criss-crossing beams of spotlights that cut through the sky, swelling crowds line the sidewalks, mesmerized by the parade of limousines bearing Hollywood's royalty to a motion-picture palace.

The growing role played by cinema and photography in the urban visual culture of the 1920s and '30s was paralleled by the development of innovative approaches to graphic communication, evident in the increasingly bold design of posters, books, and magazines. The most imaginative and influential graphic innovations of the early twentieth century were, in fact, often produced not by professional designers but by avant-garde visual artists.

One of the most famous examples of the experimental approach to typography is the *Dada Soirée* handbill (1923) designed by the German Dada artist Kurt Schwitters and Dutch avant-gardist Theo Van Doesburg. Following in the footsteps of the Italian Futurists, who had previously introduced the idea of "words in liberty," the Dada artists frequently mixed wildly heterogeneous typefaces, dispensed with symmetry in page design, and sent words and images dizzily whirling around one another. Schwitters's and van Doesburg's color lithograph announces their Kleine Dada Soirée, a raucous touring performance event that was held in several Dutch cities in 1923. The handbill is filled with words in German and French, composed of lettering in different sizes and styles running in many directions. They spell out quotations from Dadaists such as Tristan Tzara and Francis Picabia, and make cryptic references to the artistic activities of Schwitters and van Doesburg. The word DADA itself, stamped five times in red in different directions on the page, is impossible to overlook.[6]

The surge of awareness among artists that graphic communication was becoming a powerful means of public address is reflected in many of Walker Evans's photographs of the 1930s. In his travels along the Eastern seaboard of the U.S., Evans sought out scenes that testified to the proliferation of commercial billboards and posters announcing the advent of new "national" brands: Coca-Cola and Nehi soft drinks, Camel cigarettes, and Esso and Gulf gasoline. At the same time, Evans turned a connoisseur's eye to the surviving examples of the vernacular signage that he found adorning roadside fruit and vegetable stands, shoe-shine stands, barber shops, and storefront displays. He was especially attracted to uninhibited hand lettering, naïve commercial illustration, and unintentionally bizarre imagery.

Evans was constantly alert to everyday scenes and objects in which disturbing associations unexpectedly arise. Often he photographed posters altered by wind, rain, or vandalism so that their imagery takes on Surrealist overtones. *Torn Minstrel Poster, Demopolis, Alabama* (1936) is one of many deteriorating posters and showbills that Evans photographed in the South, often using tight cropping to underscore the collage-like effect of the weathered or torn paper surfaces. In this instance, one section of the minstrel-show poster has been ripped away so that a tiger and other circus animals seem to be erupting from an underlying poster into the midst of a group of black dancers. At the right edge of the photograph, a poster fragment pasted on a brick wall bears the image of a finger that is mysteriously pointing to something that lies beyond the frame. In such photographs, Evans brought a distinctly urban sensibility, schooled in the visual idioms of modernist art and alert to the unanticipated poetry of everyday life, to subjects encountered in rural and small-town America.

1 See my essay "Twenties Photography: Mastering Urban Space," in Jean Clair, ed., *The 1920s: Age of the Metropolis*, exhibition catalogue (Montreal: Montreal Museum of Fine Arts, 1991), 209-25.

2 On Bedford Lemere & Co., see Robert Elwall, *Building with Light: The International History of Architectural Photography* (London: Merrell Publishers, 2004), 52-53.

3 Raoul Hausmann, "Die neue Kunst," *Die Aktion* (Berlin), 11, no. 19/20, 1921; reprinted in Michael Erlhoff, *Raoul Hausmann, Texte bis 1933*, vol. 1 (Giessen: Edition Text + Kritik, 1982), 192. My translation.

4 Piet Mondrian, "The New Plastic in Painting," in *The New Art– The Collected Writings of Piet Mondrian*, Harry Holtzman and Martin S. James, eds. (Boston, G.K. Hall, 1986), 59.

5 The dating of Berman's photomontages is problematic, since many of the works now extant are apparently re-creations of lost pieces of the 1920s and thirties that the artist made in the latter part of the 1960s. See *Presences Polonaises*, exhibition catalogue (Paris: Centre Georges Pompidou, 1983), 233.

6 For a discussion of this work, see Deborah Rothschild, Ellen Lupton, and Darra Goldstein, *Graphic Design in the Mechanical Age: Selections from the Merrill C. Berman Collection* (New Haven, Yale University Press, 1998), 38-40.

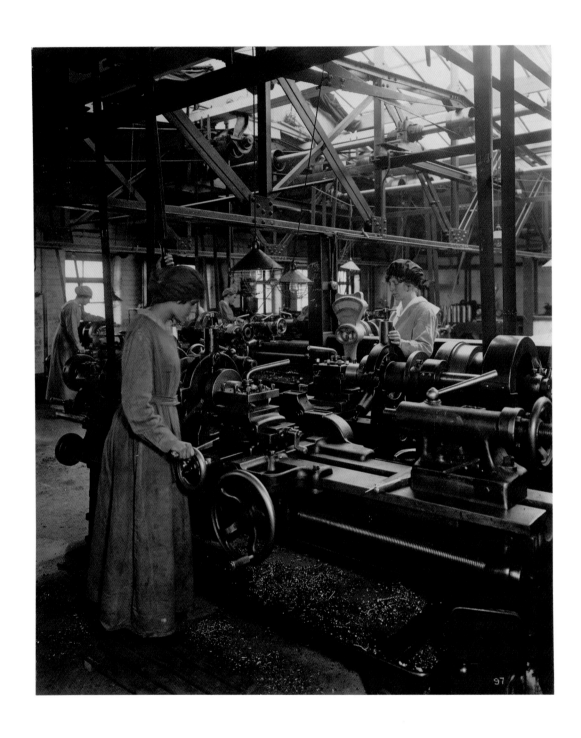

16 Harry Bedford Lemere, *Primrose Roadworks, Liverpool, a Cunard shell-works from 1914-18,* 1914-18.
Gelatin silver print, 11 3/8 x 9 3/8 in. (28.89 x 23.81 cm)

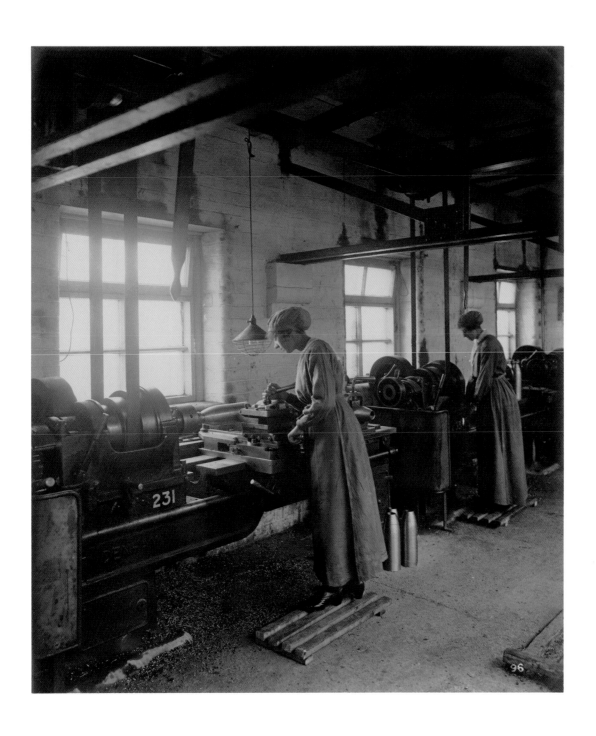

Harry Bedford Lemere, *Primrose Roadworks, Liverpool, a Cunard shell-works from 1914-18,* 1914-18.
Gelatin silver print, 11 3/8 x 9 3/8 in. (28.89 x 23.81 cm)

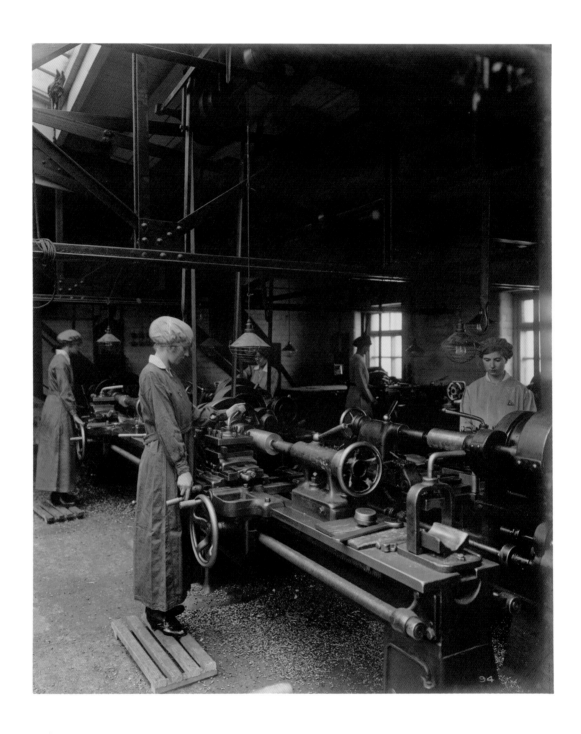

Harry Bedford Lemere, *Primrose Roadworks, Liverpool, a Cunard shell-works from 1914-18,* 1914-18.
Gelatin silver print, 11 3/8 x 9 3/8 in. (28.89 x 23.81 cm)

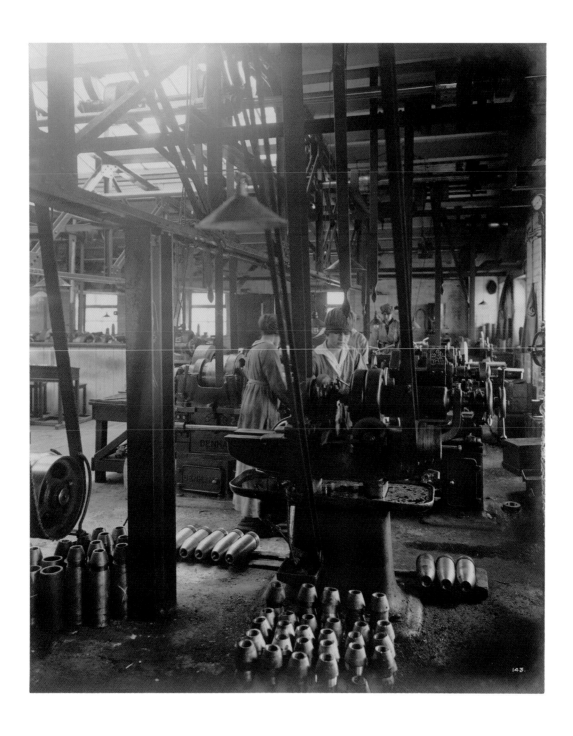

Harry Bedford Lemere, *Primrose Roadworks, Liverpool, a Cunard shell-works from 1914-18*, 1914-18. 19
Gelatin silver print, 11 3/8 x 9 3/8 in. (28.89 x 23.81 cm)

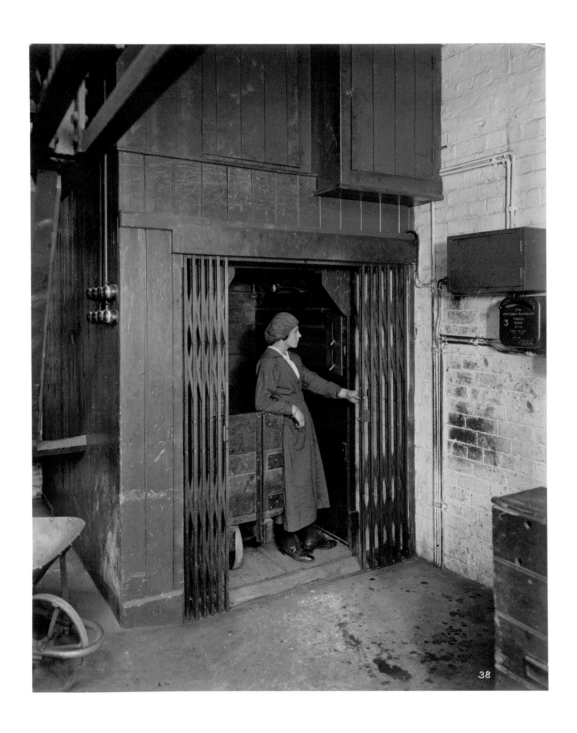

Harry Bedford Lemere, *Primrose Roadworks, Liverpool, a Cunard shell-works from 1914-18,* 1914-18.
Gelatin silver print, 11 3/8 x 9 3/8 in. (28.89 x 23.81 cm)

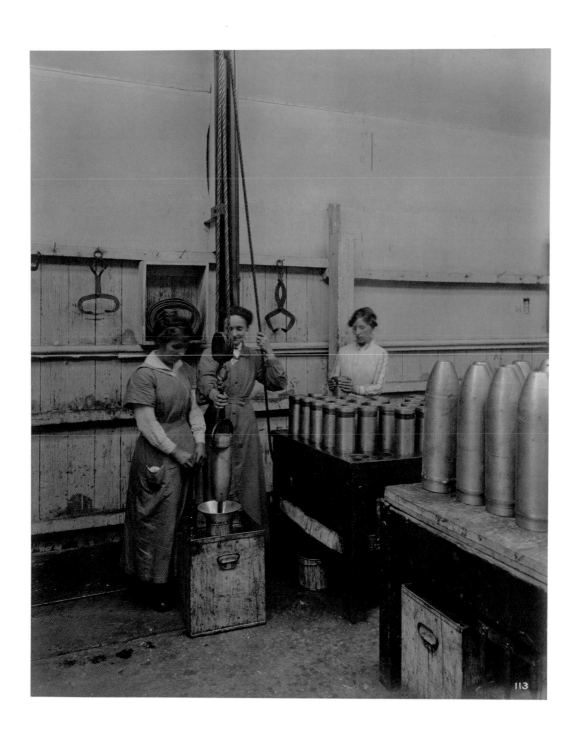

Harry Bedford Lemere, *Primrose Roadworks, Liverpool, a Cunard shell-works from 1914-18,* 1914-18.
Gelatin silver print, 11 3/8 x 9 3/8 in. (28.89 x 23.81 cm)

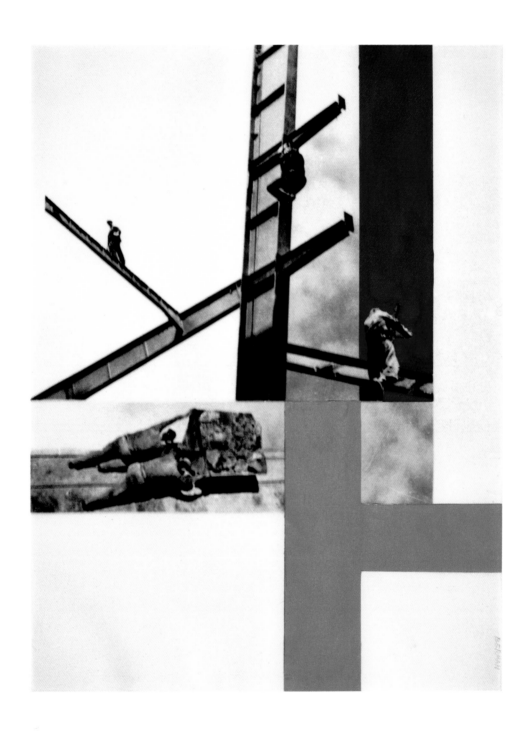

Mieczyslaw Berman, *Building, II,* 1927/1960s.
Gelatin silver print with paint and paper applied, 17 3/8 x 13 in. (44.13 x 33.02 cm)

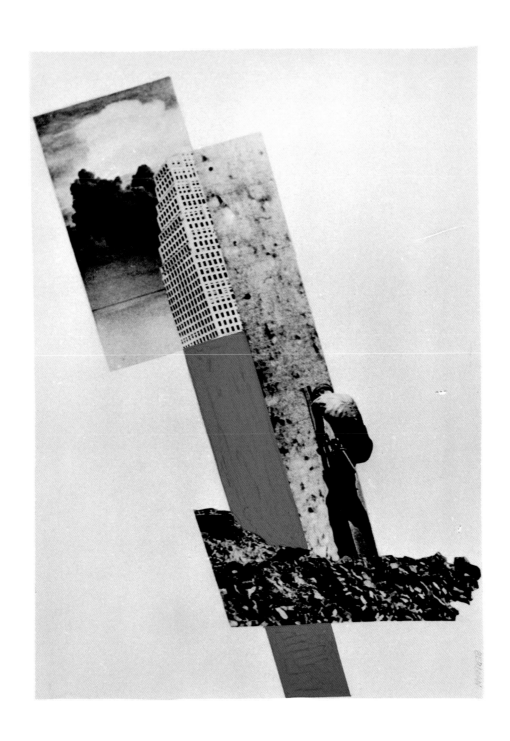

Mieczyslaw Berman, *Armor for the Nation,* 1938/1960s.
Gelatin silver print with paint, 15 1/16 x 10 1/16 in. (38.25 x 25.55 cm)

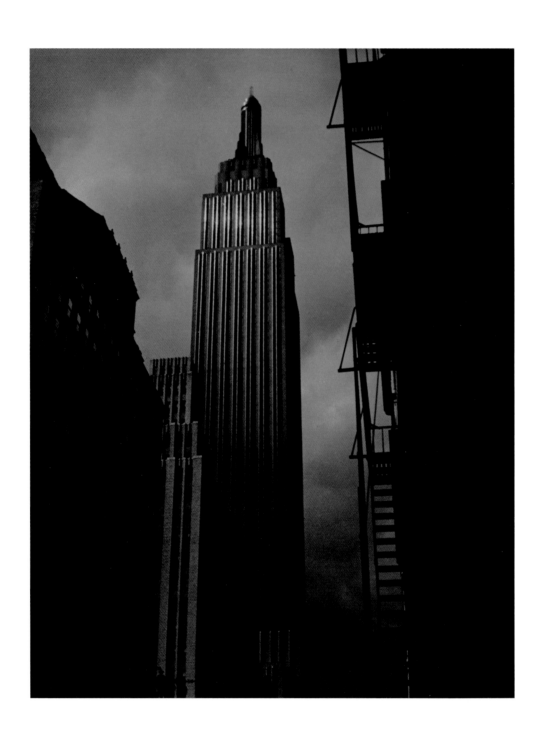

Man Ray, *Empire State Building,* 1936.
Gelatin silver print, 11 1/2 x 9 in. (29.21 x 22.86 cm)

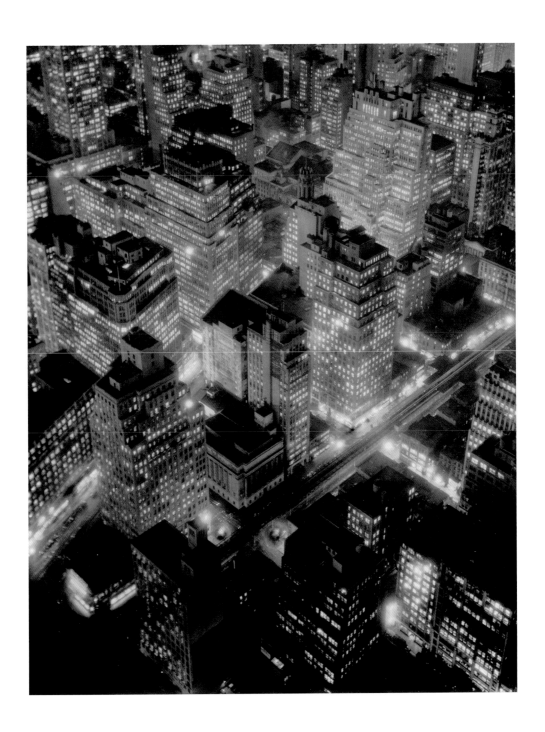

Berenice Abbott, *New York at Night,* 1934.
Gelatin silver print, 13 3/8 x 10 3/8 in. (33.97 x 26.35 cm)

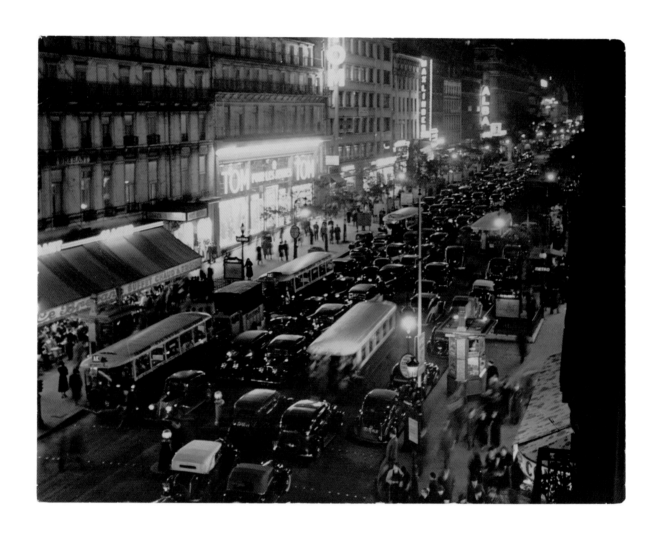

Brassaï, *Street Scene, Paris,* ca. 1930s.
Gelatin silver print, 8 3/4 x 11 3/4 in. (22.23 x 29.85 cm)

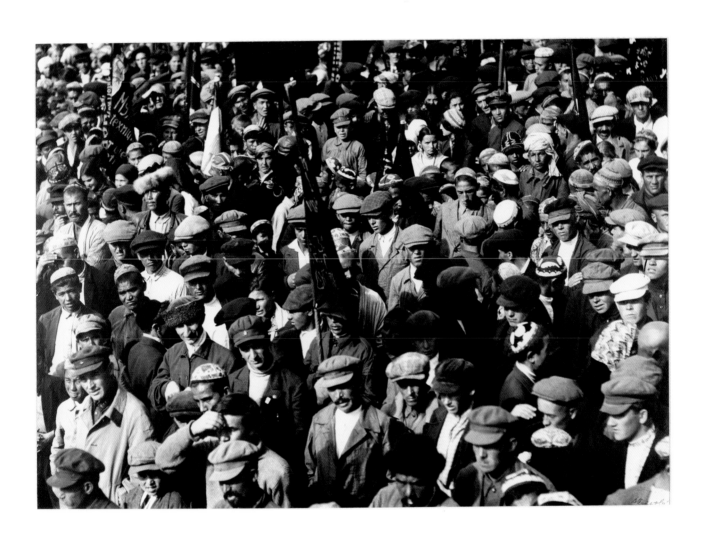

Lotte Jacobi, *Russian Workers,* 1932-33.
Gelatin silver print, 14 x 19 1/2 in. (35.56 x 49.53 cm)

Lionel Heymann, *The Shell* [bandstand], ca. 1930s.
Platinum print, 13 1/2 x 10 1/2 in. (34.29 x 26.67 cm)

Gordon Parks, *Gilbert & Barker. Five and ten cent store, Main Street, Springfield, Massachusetts,* 1945.
Gelatin silver print, 7 9/16 x 7 3/8 in. (19.21 x 18.73 cm)

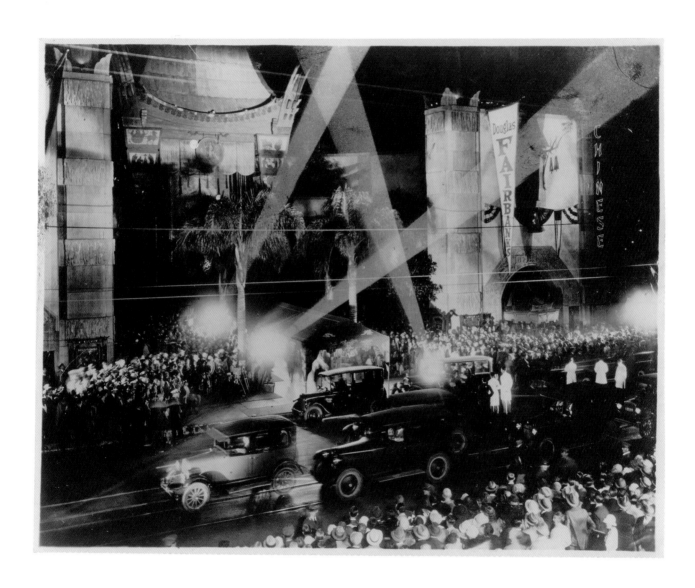

Unidentified artist, *Douglas Fairbanks Film Premiere, Grauman's Chinese Theater, Hollywood,* 1928-29.
Gelatin silver print, 7 x 9 in. (17.78 x 22.86 cm)

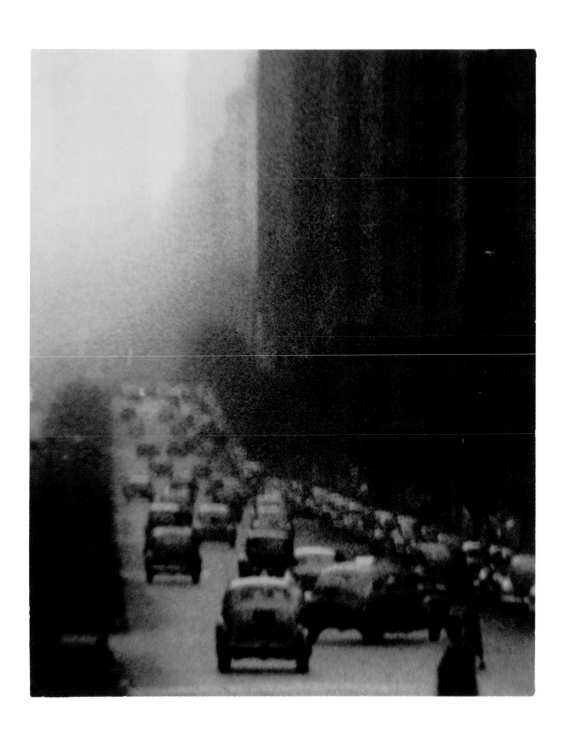

T. Lux Feininger, *New York,* 1948.
Gelatin silver print, 10 x 8 1/8 in. (25.40 x 20.64 cm)

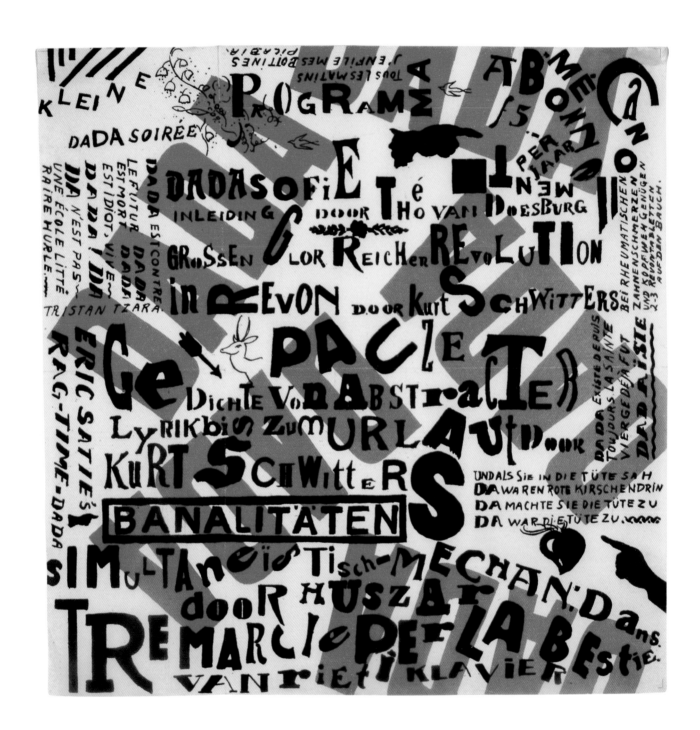

32 Theo van Doesburg and Kurt Schwitters, *Dada Soirée*, 1923.
Lithograph, 11 7/8 x 11 3/4 in. (30.16 x 29.85 cm)

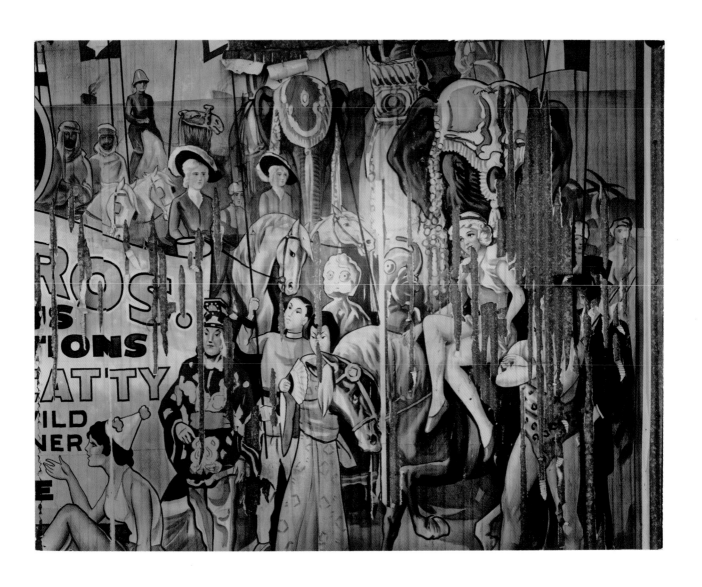

Walker Evans, *Circus Poster, Alabama,* 1935.
Gelatin silver print, 7 5/8 x 9 5/8 in. (19.37 x 24.45 cm)

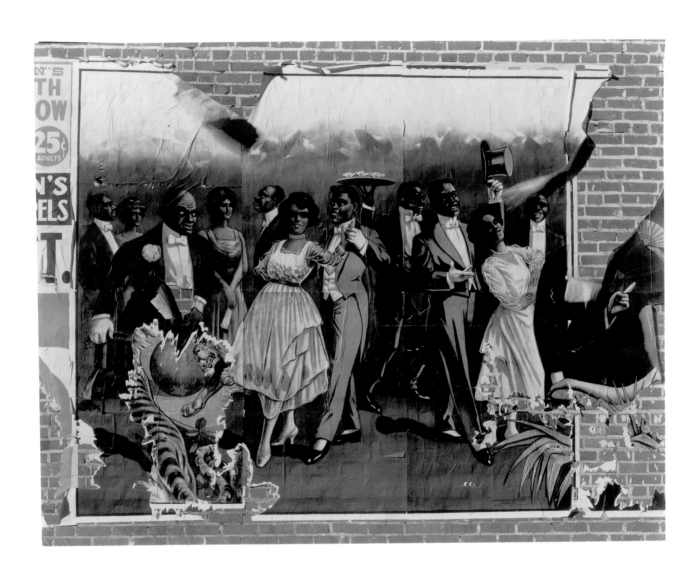

Walker Evans, *Minstrel Poster in Demopolis, Alabama,* 1936.
Gelatin silver print, 7 5/8 x 9 3/4 in. (19.37 x 24.45 cm)

BASE BALL

ALL STAR GAME OHIO STATE LEAGUE
HALLORAN PARK

LIMA-OHIO

COLORED ALL STARS
The Best Colored
Players from Toledo,
Ft. Wayne, Detroit and
Other Leading Cities.

VS.

Children 15ᶜ -- Adults 40ᶜ

The Pick of Best Players
From Northwestern Ohio
SEMI-PRO Teams

WHITE ALL STARS

ANY PLACE IN THE PARK

THE BIG GAME OF THE SEASON !!

TUES. NITE 8:30 P.M. AUG.22
UNDER LIGHTS

Unidentified artist, *Baseball All Star Game,* n.d.
Offset lithograph, 16 1/2 x 25 3/8 in. (41.91 x 64.45 cm)

John Vachon, *Girl on Lobster,* 1938.
Gelatin silver print, 7 7/16 x 9 5/8 in. (18.89 x 24.45 cm)

Jack Delano, *Painting on a barn near Thomsonville, along Route 5, Conn.,* 1940.
Gelatin silver print, 8 x 10 in. (20.32 x 25.40 cm)

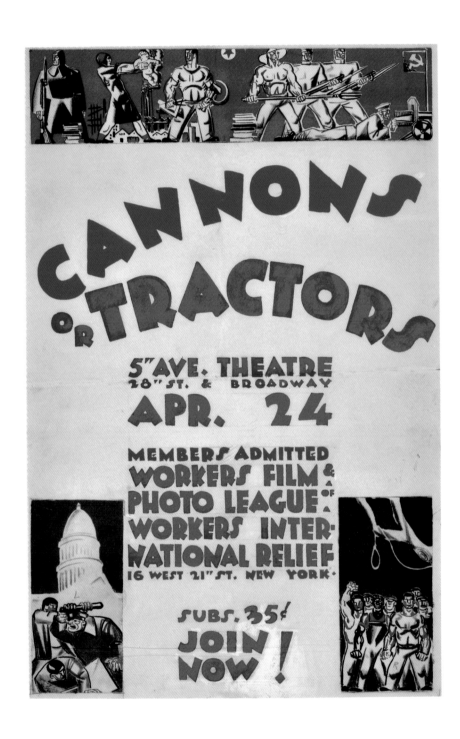

38 Hugo Gellert, *Cannons or Tractors* [maquette for Workers Film and Photo League poster], 1931.
Collage, 17 1/2 x 11 1/2 in. (20.32 x 25.40 cm)

Rosalie Gwathmey, *Paris, France,* 1949.
Gelatin silver print, 7 1/4 x 9 3/8 in. (18.42 x 23.81 cm)

Rosalie Gwathmey, *Charlotte, North Carolina,* 1944.
Gelatin silver print, 7 1/2 x 9 5/16 in. (18.42 x 23.81 cm)

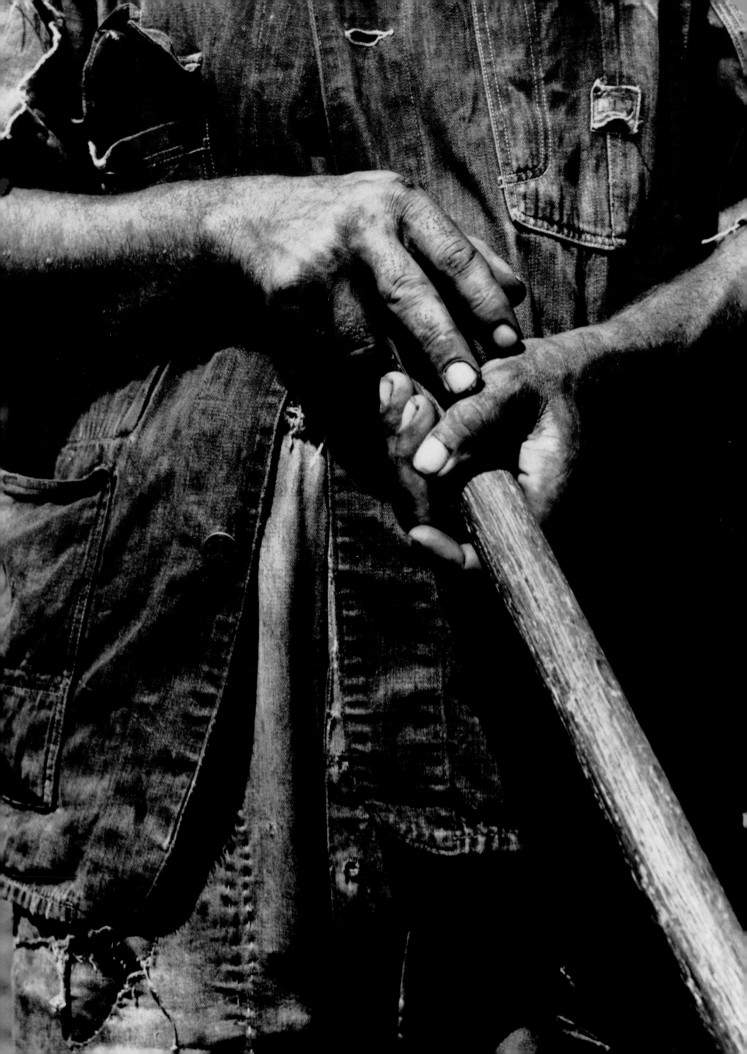

THE MODERNIZATION OF RURAL LIFE

By Kristen Lubben

The small team of photographers working for the Farm Security Administration (FSA) documented America during a time of broad social and political transformation, as the country struggled to find its way out of the crisis of the Great Depression. But their images also reveal another, equally significant transition: the country's profound and lasting shift from a rural, agrarian society to a fully industrialized, urban and suburban one. This small selection of photographs in the Daniel Cowin Collection from the FSA and its precursor, the Resettlement Administration (RA), spans a period from the establishment of the agency to after the attack on Pearl Harbor, and suggests the monumental changes that modernization was effecting or accelerating, particularly in rural areas, where mechanized farming compounded the problems faced by farmers already hard-hit by drought and soil erosion.

The mandate of the photographic section was to promote the efforts of the RA, which was set up in an effort to help Americans, particularly the rural poor, survive the Depression, as well as to reform and manage the swiftly changing agriculture industry. At the same time, there was a recognition that the transformation of rural economic and social organization endangered traditional culture and folkways. Exhibiting a national passion for Americana,[1]

the photographic section actually functioned more often in its implementation as a poignant or even sentimental celebration of a dying way of life than as advocacy for modern, efficient government management. Elements of these seemingly contradictory agendas can be seen in this small selection of images, as can the gradual shift in the agency's focus from its problem-oriented early days, to its celebration of the small farmer at the end of the decade, to an emphasis on rallying the public as World War II approached.

Two photographs in the Daniel Cowin Collection by one of the least-known Resettlement Administration photographers, Austrian-born Theodor Jung, highlight ambiguities in the agency's portrayal of the encroachment of modernization and technological advancement on traditional ways of life in rural America. The subjects of both photographs are dated but apparently serviceable wood-burning stoves in modest kitchens. The first image, captioned "Interior of cabin, Garrett County, Maryland," was taken in September 1935, not long after the establishment of the Resettlement Administration. On his first assignment with the RA, Jung was sent to Maryland to record a RA program to aid miners who were thrown out of work when the local mines closed. Showing a slightly more disheveled interior with

peeling wallpaper, the second image, "Interior of a rehabilitation client's house, Ohio," was taken in April of the following year. In a 1965 interview, Jung indicated that he intended his work in Maryland to serve the RA's goals, saying, "These people needed resettling and the pictures I took showed why they needed it. The barrenness of the soil–it was impossible for them to make a decent living in agriculture and mining was all mined out so I went into the homes and showed the barrenness of the living, the little possessions that they had and yet I had of course certain admiration because many of them made very strong efforts to live in a clean, tidy, very orderly manner despite their extreme poverty...."[2]

At the same time, Jung was trained in graphic arts and spent time documenting rural American crafts: perhaps the stoves were a mark of his appreciation of vernacular American design, a passion shared by his agency colleague, Walker Evans. Jung was also an admirer of Atget's documents of Paris, which he had seen at Julien Levy's gallery in New York, and he had imitated the photographer's descriptive style while a student in Vienna. Jung may have seen his work with the RA as analogous to Atget's project to record every seemingly banal corner of his changing city.

The Resettlement Administration documentary project was initiated by Rexford Tugwell, a former Columbia economics professor appointed to the post of assistant secretary of agriculture. Tugwell, head of the newly formed Resettlement Administration, recognized that not all of the federal assistance programs united under the RA banner would have popular support, so he created an Information Division to promote the agency's activities. In 1935, he hired his former Columbia teaching assistant Roy Stryker to direct the photographic activities of the agency, with the title Chief of the Historical Section of the Information Division of the Resettlement Administration. Stryker had used photography extensively as a teaching tool in his economics classes at Columbia and had edited the photographs for Tugwell's textbook *American Economic Life and the Means of Its Improvement*, so he was adept at the use of photography to illustrate the effects of economic and social programs. The division's initial purpose was to garner public sympathy for the intended recipients of government aid, with an emphasis on the rural poor and those dislocated by such forces as farm mechanization and soil erosion.[3] The project, which became part of the Farm Security Administration in 1937, soon expanded into a broader-reaching "portrait of America," and as World War II approached, the focus shifted again to more upbeat images of war-readiness and patriotism. At its height, the agency employed half a dozen or more photographers, and ultimately generated some 270,000 photographs, which were used in magazines, government publications, and exhibitions.

Although it was a direct response to the crisis of the Great Depression, the ideological framework for the FSA photography project was developed earlier in the century. In her book *Symbols of Ideal Life: Social Documentary Photography in America, 1890-1950*, Maren Stange describes the impact of the "scientific management" movement of Frederick Winslow Taylor on reformist social engineers of the 1920s, who held that high-level management could be a tool of social change. Tugwell incorporated their theories and was an advocate of the reform of rural life and agriculture based on the industrial model. According to Stange, "... Tugwell had come to consider agriculture the particular site of the struggle for planning and coordination of production under the leadership and control of govern-

ment-sanctioned experts."[4] Like other New Deal agricultural planners, Tugwell concluded that the efficient and modernized agricultural system that he promoted would mean the emigration of many rural citizens to growing urban manufacturing centers. Stryker's views were greatly shaped by Tugwell, who was not only his teacher and mentor, but the person who had drawn him to Washington to develop the photographic project. In "The Record Itself: Farm Security Administration Photography and the Transformation of Rural Life," Stange writes that though Stryker was not himself a theorist, "his conception of the FSA photography project was clearly influenced by a progressive vision that welcomed modernization and technocratic efficiency as a way to 'uplift' standards of rural and urban American life."[5]

Aligning himself with the larger aims of the agency, Stryker hoped that his photographers would serve its purposes. However, some of his staff members were more compliant than others. Walker Evans, who, along with Carl Mydans, became part of Stryker's team when photography was consolidated within the RA, was notoriously independent and used the opportunities that the agency afforded him—travel, film, a job in a time when they were scarce—to produce work that adhered more to his own artistic vision than the demands of the agency. And the California-based Dorothea Lange was already a well-established photographer with a deep engagement with social issues by the time she joined the RA in 1935. She drew her understanding of the economic underpinning of the conditions she was photographing from working with her husband, Berkeley economist Paul Schuster Taylor, rather than from Stryker and the standard copy of J. Russell Smith's geography-economics text *North America* that he gave to each of his photographers.

Lange was certainly aware of the high toll that modernization, particularly the mechanization of farming, was taking on rural life. In 1939, she and Taylor coauthored *An American Exodus: A Record of Human Erosion*, a photo-and-text book on the vast migrations away from small farms in the South and plains. The second photograph in the book is an image included in the Daniel Cowin Collection, Lange's *Hoe Culture, tenant farmer near Anniston, Alabama*, 1937, a full-torso study of a farmer's carefully and repeatedly patched work clothes (with the words "Pay Day" on the buttons of his shirt). The subject's face, elbows, and legs are outside of the tight frame of the image, and at its center, the subject leans on the handle of his hoe, a soon-to-be antiquated farm implement that acts as support or crutch for the laborer. As Sally Stein writes in "Peculiar Grace: Dorothea Lange and the Testimony of the Body," the figure leaned or propped against a support is a recurring motif in Lange's work, apparent as early as her 1932 classic *White Angel Bread Line*, and indicates both the down-and-out victim of the Depression who literally can't support himself, and, Stein proposes, Lange's own disability.[6] The image was part of a series of images that Lange titled "Hoe Culture," depicting both white and black laborers in Alabama, and was included in Richard Wright and Edwin Rosskam's 1941 book *Twelve Million Black Voices*, where it ostensibly represented a black farmer. Face obscured and weather-tanned arms and neck exposed, the figure's race is ambiguous. Variant images show that the farmer pictured is actually white, but "hoe culture," the traditional manual labor of cotton farming, as Lange's photographs show, crossed color lines, and the laborer's job was in danger regardless of race.

Another Lange work in the Daniel Cowin Collection is a June 1937 photograph, taken in Hall

County, Texas, of an abandoned tenant house set among imposing rows of machine-cultivated fields. The image is nearly identical to a photograph that Lange took in Childress County, Texas, the following year, which is reproduced in *American Exodus.* Included in a section titled "Plains," the photograph is captioned "Tractors Replace Not Only Mules, but People. They Cultivate to the Very Door of the Houses of Those Whom They Replace. Childress County, Texas. June 1938."[7] In Taylor's text accompanying this section, he writes, "The process of displacement from the land started by depression and drought, now is receiving impetus from the machine."[8] Driven by the necessity to produce goods more cheaply, and in order to avoid sharing cash payments from the agricultural adjustment program with tenant farmers, landowners shifted to a system of mechanized methods fueled by day laborers. Lange's low camera angle emphasizes the scale and uniformity of the machine-made rows of land in the foreground, making the tenant cabin appear dwarfed and engulfed, vividly representing the way that the residents of the cabin were driven out by modernized farming practices.

In a prescient summation that offers a moving rejoinder to Tugwell's advocacy of modernization, Taylor called mechanization "a process without end," observing that "scholars of the future may well take the view that mechanization on the plains enabled farmers to cut costs of production and to recapture a portion of the slipping export market. But the price of such progress in terms of social disorganization and human misery comes high on the plains. . . . When the rains return to the plains the displaced tenants will probably not come back, for the new methods of farming leave them no place."[9]

Arthur Rothstein, unlike Evans and Lange, was a loyal mainstay of the FSA project, particularly in its early years. A former student of Stryker's at Columbia, Rothstein was hired by Stryker in 1934 to work with him as copy photographer on a planned *Encyclopedia of American Agriculture,* which he proposed to the Agricultural Adjustment Administration, precursor to the RA. Rothstein was one of the most prolific of FSA photographers, and he was the creator of some of the best-known images in the file, including one much-reproduced image, taken in April 1936 in Cimarron County, Oklahoma, of a father and his two young sons fleeing a rising dust storm. He became the focus of controversy when the Fargo *Evening Forum* revealed that his May 1936 photograph of a steer skull on the drought-cracked earth of Pennington County, South Dakota, was "faked"–he had moved the skull in order to find the most dramatic image. The story sparked criticism from the Republican-dominated press that the RA was involved in photographic trickery to exaggerate drought conditions.

Despite these setbacks, Stryker was grateful to Rothstein for his committed and enthusiastic participation, repaying his former student's dedication by featuring his photographs in Resettlement publications and in a prominent 1938 exhibition of photographs at Grand Central Terminal in New York. One of the most popular prints in that exhibition was one of migrant farmer Vernon Evans leaning against his loaded-up car, which is inscribed on its back with the phrase "Oregon or Bust." In *Mind's Eye, Mind's Truth: FSA Photography Reconsidered,* James Curtis recounts the story of how Rothhstein captured this image. Rothstein had been napping in his car alongside the road near Missoula, Montana. As Evans and three companions drove by, they honked and shouted at Rothstein's government car. The young photographer, noticing the archetypal slogan of the westward-bound nineteenth-century

pioneer, chased the car down and asked Evans if he could photograph the group.[10] Among the works in the Daniel Cowin Collection is a variant of this image, showing two of Evans's companions and bearing the caption "South Dakota family leaving the grasshopper-ridden and drought-stricken area for a new start in Oregon or Washington."[11] In contrast to other photographs of migrants with all of their worldly possessions and several young children packed into their cars (like those by Lange)—in which the car signals rootless migrant labor[12]—this group of jaunty and intrepid young people invokes the frontier traditions of the West, much celebrated in the 1930s, rather than the devastation of the Depression or environmental problems.

During the first two years of the historical section's existence, the focus of the agency was on documenting the worst of rural poverty. In 1936, Tugwell left the agency, which may have made it easier for Stryker to think of branching out from the original mandate. In spring of that year, Stryker's sociologist friend Robert Lynd encouraged him to embark on a photographic study of life in small-town America. Lynd contended that this was a segment of American society directly related to rural problems, one that was fading away and would soon be lost.[13] The idea captured Stryker's imagination. He soon issued a shooting script for his photographers entitled "Suggestions recently made by Robert Lynd (co-author of Middletown) for things which should be photographed as American Background." The script is an exhaustive listing of suggested social activities and public and private spaces that the photographers should try to cover, beginning with, "Home in the evening. Photographs showing the various ways that different income groups spend their evenings, for example: Informal clothes, Listening to the radio, Bridge."

Russell Lee was hired to replace Carl Mydans when the latter left to become staff photographer at *Life* magazine in 1936, and, alongside Rothstein, soon became the other pillar of the project and the most productive member of the agency. Lee was from an affluent Midwestern family, and Stryker hired him to focus on his home region. He began at the agency as its direction was changing. His 1937 photograph of a North Dakota farm woman listening to her radio recalls Stryker's memo and reflects the less-downtrodden look of FSA work from this period. The strong flash evident in the photograph illuminates the radio as well as the wall decorations in the home and indicates the interest in revealing all available details of the woman's surroundings. In a 1965 interview, Lee describes his understanding of the agency's undertaking, which contrasts with Jung's more problem-oriented description of his work at the agency's outset. Lee says, "We were just interested in building a file which would show just about, well, everything there was . . . whenever they [his subjects] asked me, 'What are you doing out here taking pictures?' I said, 'Well, I'm taking pictures of the history of today.'"[14]

Rothstein left the FSA in 1940 to work at *Look* magazine, and was replaced by Jack Delano, a photographer who had already established himself as a social documentarian through his work covering coal-mining conditions in Pennsylvania, a project funded by the Federal Art Project. On Delano's first trip for the agency, he and his wife and collaborator Irene Delano were sent to photograph New England in the fall, with the following instructions from Stryker:

Please watch for "Autumn" pictures, as calls are beginning to come in for them and we are short. These should be rather the symbol of Autumn,

particularly in the Northeast–cornfields, pumpkins, raking leaves, roadside stands with fruits of the land. Emphasize the idea of abundance–the "horn of plenty" and pour maple syrup over it–you know; mix well with white clouds and put on a sky-blue platter. I know your damned photographer's soul writhes, but to hell with it. Do you think I give a damn about a photographer's soul with Hitler at our doorstep? You are nothing but camera fodder for me.[15]

The letter is clearly meant to be humorous and tongue-in-cheek, but it indicates that yet another shift was underway in the agency, toward documenting traditional rural Americana not as a vanishing way of life, but with the intent that such images would solidify feelings of patriotism and national identity and thereby support the war effort. Delano's much-reproduced photograph of Mr. and Mrs. Andrew Lyman, a jovial Polish tobacco-farming couple in Connecticut, was taken on this first trip through New England. Delano cited this photograph as an example of the often-overlooked humor in the file, and also referred to his work in this area of Connecticut as emblematic of the diversity of America.[16] The photograph was included in Edward Steichen's 1955 *Family of Man* exhibition, in a section celebrating agricultural labor. According to Delano, Steichen referred to him as the "artist in the group" for his interest in arranging compositions, carefully setting up lighting conditions, and posing his subjects, rather than documenting them as he came across them.[17] Like Rothstein, Delano saw no deception in such efforts, but felt that he was amplifying or clarifying an existing image, not creating it.

John Vachon came to the FSA in 1936 as assistant messenger. His job was to run errands, caption prints, and maintain the organization of the file. With Stryker's encouragement, he borrowed a camera from the office in 1937 and began taking photographs on his own around Washington, DC, but was not officially classified as a photographer until 1941. He stayed with Stryker through the absorption of the FSA by the Office of War Information, and moved with him to Standard Oil in 1943, joining the staff of *Look* after the war.

In June 1941, Vachon took a series of photographs of an FSA trailer camp for defense workers a quarter mile from the General Electric plant in Erie, Pennsylvania (he also took photographs of similar trailer camps in Iowa, Michigan, and Virginia). According to the photograph's caption, "There are 200 trailers here, occupied by Childless couples and by families of one or two children." Vachon, who was more aware of the demands of the photo file than other photographers, having been its organizer and manager for years, photographed the trailer camps thoroughly inside and out, detailing the agency's programs to enable the war effort. The majority of the images emphasize the cleanliness and efficiency of the living quarters, complete with built-in furniture and modern kitchens. Some of the families are identified by place of origin, such as Alabama, and one wonders if the implication is that these new living quarters, however small, are far preferable to whatever they left behind. The movement of people from rural areas to work in factories or construction for the defense industry also represents another branch of the "American exodus."

The latest image in the collection is a February 1942 photograph of two young men "washing up for dinner on Pat McRaith's farm, Meeker Co., Minnesota," part of an extended portrait of the McRaith family farm. This series was taken in Vachon's own home state and also included photos of farmers in

surrounding areas registering for selective service. The same month that Vachon took this photograph, Stryker sent out another shooting script that was geared toward "any signs which indicate a country at war." Under section ten, "People," Stryker writes, "*we must have at once*: Pictures of men, women, and children who appear as if they really believed in the U.S. Get people with a little spirit. Too many in our file now paint the U.S. as an old person's home and that just about everyone is too old to work and too malnourished to care much what happens. . . . We particularly need young men and women who will work in our factories, the young men who will build our bridges, roads, dams and large factories."[18]

In an earlier moment in the agency's history, this photograph of a farm family might have focused on the threat of losing their land, how their traditional way of life was changing, or even the emblematic detail of a water pump rather than running water. But in 1942, it probably also read as an image of the sturdy young men from America's heartland who were ready to leave the farm, possibly for good, to fight in World War II. The vaguer cause of recording the vanishing traditions of the rural and small-town life came to an end as the FSA photography section was absorbed into the Office of War Information in 1942. Its demise was summed up by Jean Lee, wife of Russell Lee: "The war effort was so intensified. . . . This was no time to be doing the sort of background material we were equipped to do. . . . The terrific problems were there, but the war was too urgent, we didn't have time."[19]

The ambivalent or even conflicting strains in the representation of modernization and tradition in these photographs may be indicative of opposing impulses in the photographic section's vision of its role: promotional arm for a governmental reform agency or national archival project reflective of the renewed interest in and romanticization of vanishing traditional ways of life. This sample of photographs in the Daniel Cowin Collection suggests that the FSA photography project bears further examination through the lens of modernization, as even within this small group, there is a range of approaches that point to differences between photographers and changes from the agency's inception to its demise, reflective of the complex attitudes of the time and within the Farm Security Administration.

Thanks to Maren Stange and Sally Stein for their assistance with this essaay.

1 Alfred Haworth Jones, "The Search for a Usable American Past in the New Deal Era," *American Quarterly* 23, no. 5 (December 1971), 717: ". . . the renewed passion for Americana . . . flowed through the 1930s like a current." Jones also relates the 1930s romanticization of America's agrarian past and pioneer spirit to a turning away from Europe: "In America, as elsewhere, the Depression encouraged an insular nationalism which colored the interpretation of history. . . . the nationalism of the decade stimulated an emphasis upon the uniqueness of American ideals and values, not the purity of any single racial or cultural stock. In many ways, American writers turned their backs on the Old World. Not the seaboard nation of smallclothes, transatlantic citizens and "Good Feelings" attracted them, but the interior country with its homespun garb, provincial politics and sectional animosities. The pioneer farmer much more than the merchant trader represented the American character for these 20th century citizens. They cherished his frontier penchant for tackling problems head-on. And like him, they believed that the solutions lay close at hand. Europe could provide neither excuses or guidance" (718).

2 Theodor Jung, interview by Richard K. Doud, January 19, 1965, Archives of American Art, New York, 7.

3 "The section's original mandate was to prepare finished reports by a battery of economists, sociologists, statisticians, photographers, and other specialists. In fact, it produced and maintained a file of still photographs and supplied copies of the pictures for news releases, put out a variety of internal and external publications, and prepared a wide range of exhibits." Carl Fleischhauer and Beverly W. Brannan, eds., *Documenting America, 1935-1943* (Berkeley and Los Angeles: University of California Press, 1988), 3.

4 Maren Stange, *Symbols of Ideal Life: Social Documentary Photography in America, 1890-1950* (Cambridge: Cambridge University Press, 1989), 97.

5 Maren Stange, "'The Record Itself': Farm Security Administration Photography and the Transformation of Rural Life," in Pete Daniel et al., *Official Images: New Deal Photography* (Washington, DC: Smithsonian Institution Press, 1987), 2.

6 Sally Stein, "Peculiar Grace: Dorothea Lange and the Testimony of the Body," in *Dorothea Lange: A Visual Life* (Washington, DC: Smithsonian Institution Press, 1994), 57–89. Lange had polio as a child, which left one leg shorter than the other, causing her to limp and require special shoes as an adult. Stein also describes another source for the figure with a prop or crutch: ". . . the cane that Roosevelt sought to dispense with in public was transferred from the absent figure of the candidate to the constituents he sought to represent by identifying their pressing social needs. Other cartoonists and graphic artists adopted similar strategies of dissociating the cane from Roosevelt and grafting it onto other figures intended to symbolize the common man, the forgotten farmer, or the down-and-out man on the street" (72).

7 Dorothea Lange and Paul Schuster Taylor, *An American Exodus: A Record of Human Erosion* (New York: Reynal and Hitchcock), 73.

8 Ibid., 86.

9 Ibid., 88.

10 James Curtis, *Mind's Eye, Mind's Truth: FSA Photography Reconsidered* (Philadelphia: Temple University Press, 1989), 16.

11 A variant of the image on the Library of Congress website bears the more complete caption, "Vernon Evans and family of Lemmon, South Dakota, near Missoula, Montana. Leaving the grasshopper-ridden and drought-stricken area for a new start in Oregon or Washington. Expects to arrive at Yakima in time for hop picking. Makes about two hundred miles a day in Model T Ford. Live in tent." (http://lcweb2.loc.gov/pp/pphome.html, call number LC-USF34-005008-D.)

12 Lange and Taylor, *An American Exodus*, 146. "To even the poorest of these [migrant workers] an automobile is a vital necessity and the cost of its operation cuts a large figure in the family budget. The car must be fed gasoline and oil to make the next harvest, or to get to and from the fields, and its wheels must be kept shod before the feet of the children."

13 F. Jack Hurley, *Portrait of a Decade: Roy Stryker and the Development of Documentary Photography in the Thirties* (Baton Rouge: Louisiana State Press, 1972), 98.

14 Jean and Russell Lee, interview by Richard K. Doud, June 2, 1964, Archives of American Art, New York, 28. Jack Delano supports this understanding of Stryker's encyclopedic approach. In his interview with Doud, he says that Stryker had "this collector's attitude [toward what should be photographed] and this idea that everything is useful and you've got to have it, and if you don't need it now, you'll need it later, or somebody else is going to need it. . . . it is valuable . . . because of the material contained in it about social mores of the time, about . . . well, things have changed already considerably just in these twenty-odd years and the files gives [sic] us such a vivid picture of what things were like at that time, not only in the depressed areas but in all the other things we covered. It was the temper of the times." Jack and Irene Delano, interview by Richard K. Doud, June 12, 1965, Archives of American Art, New York, 30.

15 Hurley, *Portrait of a Decade*, 148.

16 Delano, interview, 23. "The Poles spoke nothing but Polish almost. Very surprising, being so close to New Bedford, which is whaling tradition and what you would think of as American as American can be, and yet these other people [in the Polish community and the nearby Jewish community] consider themselves just as American as anyone else."

17 Ibid., 10.

18 Roy Stryker and Nancy Wood, *In This Proud Land: America 1935–43 as Seen in the Farm Security Administration Photographs* (Greenwich, CT: New York Graphic Society, 1973), 188. Vachon seems not only to have been taking photographs to contribute to Stryker's file of images of war-readiness, but also to have questioned the role that his photography played in the war effort. In a 1965 interview, Richard K. Doud asked Vachon if he ever had trouble photographing people. His reply was, "No, not until the war started, when I felt–well, of course then we were still called Farm Security, but we were in some way connected with, and the pictures were being used by, O.W.I. But I had a slight feeling in those days of 'What am I doing?' and occasionally, when somebody, when a farmer would find out that I was working for the government and I was taking his picture, it seemed a little ridiculous to him–why wasn't I in the Philippines?" John Vachon, interview by Richard K. Doud, April 28, 1964, Archives of American Art, New York, 9.

19 Jean and Russell Lee, interview by Richard K. Doud, June 2, 1964, Archives of American Art, New York, 34.

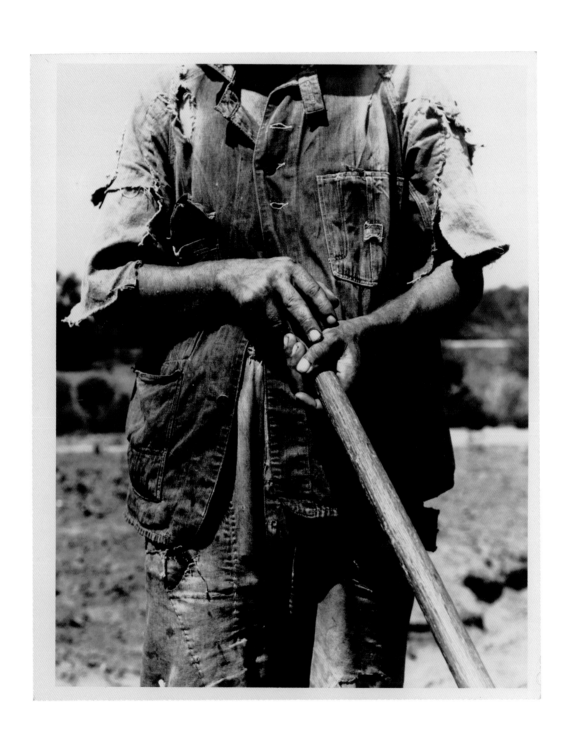

Dorothea Lange, *Hoe culture. Tenant farmer near Anniston, Alabama*, 1936.
Gelatin silver print, 8 x 10 in. (20.32 x 25.40 cm)

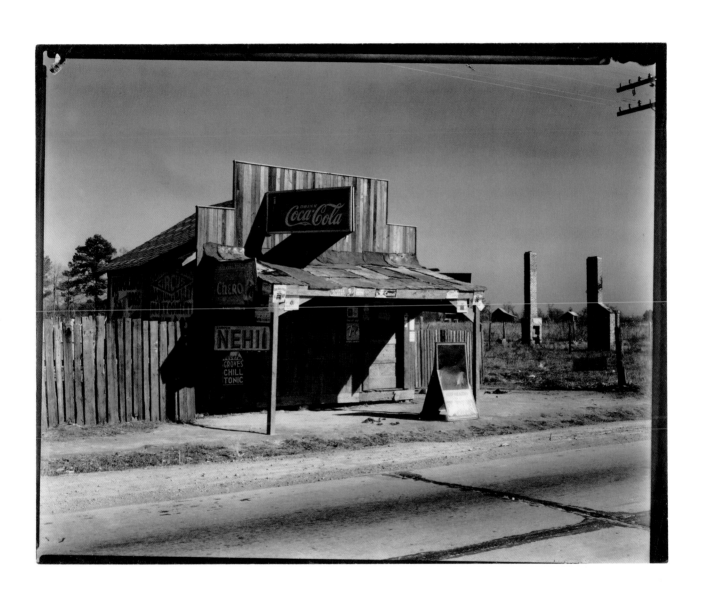

Walker Evans, *Coca Cola Shack in Alabama,* 1935.
Gelatin silver print, 8 x 10 in. (20.32 x 25.40 cm)

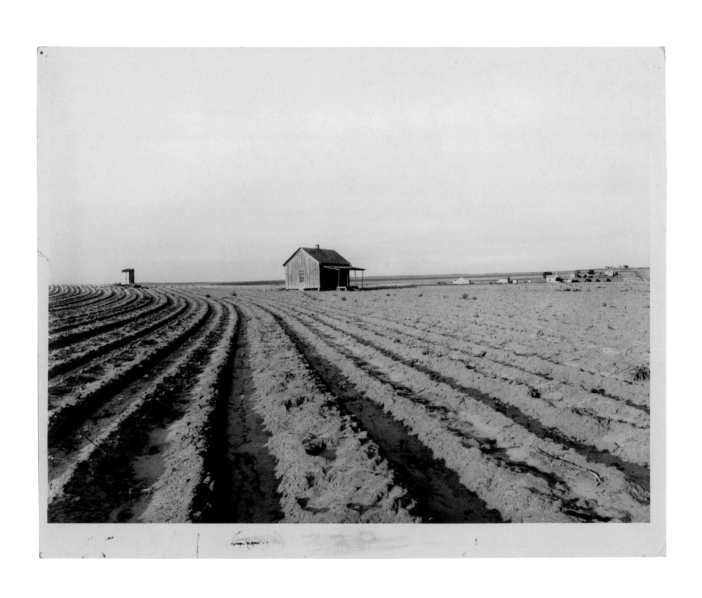

54 Dorothea Lange, *Abandoned tenant house. Hall County, Texas,* 1937.
Gelatin silver print, 8 x 10 in. (20.32 x 25.40 cm)

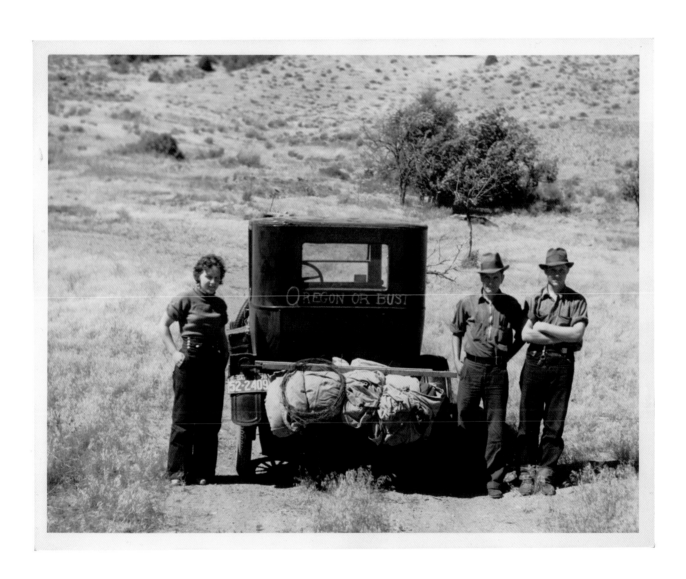

Arthur Rothstein, *Oregon or bust. Leaving South Dakota for a new start in the Pacific Northwest,* 1936.
Gelatin silver print, 8 x 10 in. (20.32 x 25.40 cm)

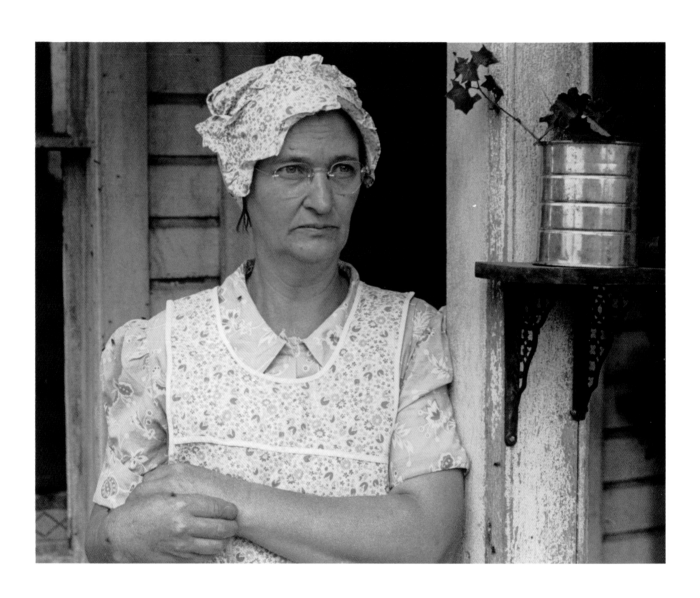

Ben Shahn, *Housewife, Small Town, Ohio,* 1935-38.
Gelatin silver print, 8 x 10 in. (20.32 x 25.40 cm)

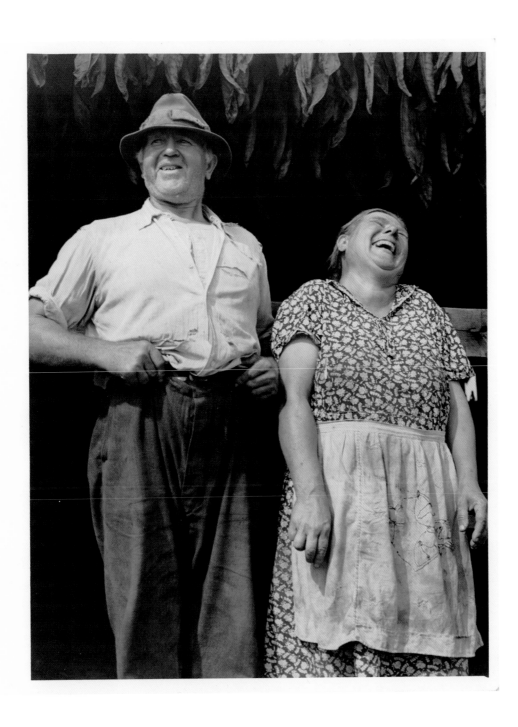

Jack Delano, *Mr. and Mrs. Andrew Lyman, Polish tobacco farmers near Windsor Locks, Conn.,* 1940.
Gelatin silver print, 8 x 10 in. (20.32 x 25.40 cm)

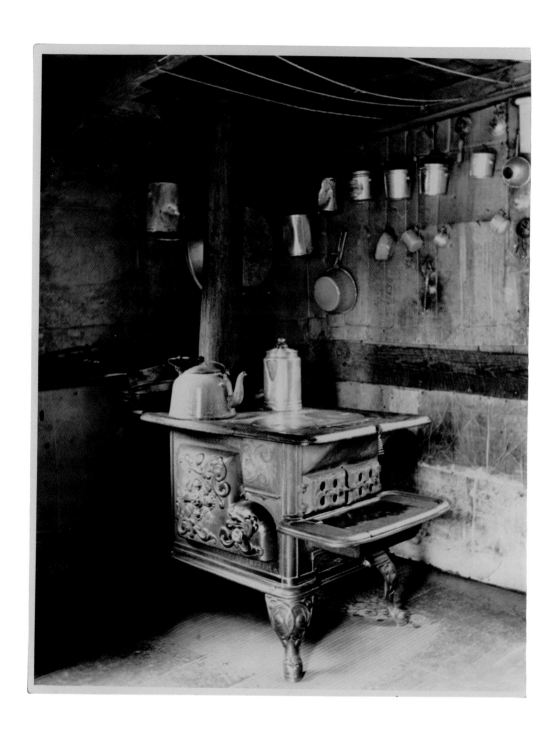

Theodor Jung, *Garrett County, Maryland. Interior of a house,* 1935.
Gelatin silver print, 8 x 10 in. (20.32 x 25.40 cm)

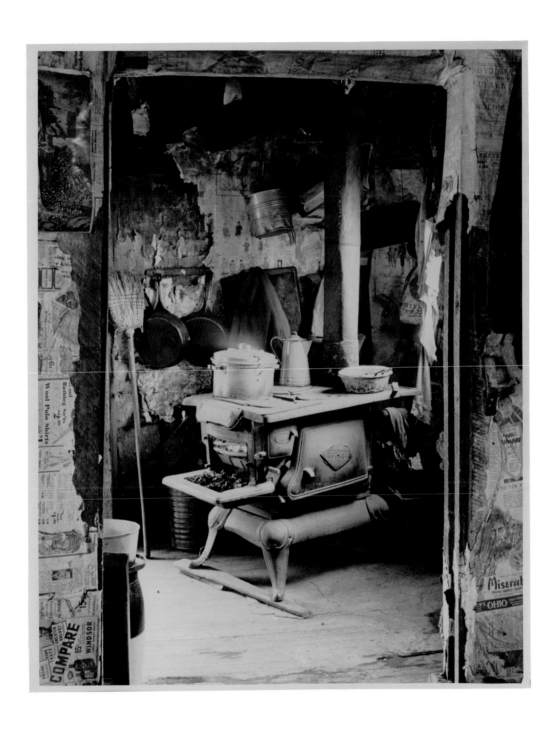

Theodor Jung, *Interior of rehabilitation client's house, Ohio,* 1936.
Gelatin silver print, 8 x 10 in. (20.32 x 25.40 cm)

60 Russell Lee, *Mother of John Lynch, farmer, Williams County, North Dakota. She was one of the earliest homesteaders,* 1937.
Gelatin silver print, 8 x 10 in. (20.32 x 25.40 cm)

John Vachon, *Washing up for dinner on Pat McRaith's farm, Meeker Co., Minnesota*, 1942.
Gelatin silver print, 8 x 10 in. (20.32 x 25.40 cm)

John Vachon, *FSA trailer camp for defense workers,* 1941.
Gelatin silver print, 8 x 10 in. (20.32 x 25.40 cm)

Jack Delano, *At the Vermont State Fair, Rutland,* 1941/1985.
Dye transfer print (print made in 1985), 8 x 10 in. (20.32 x 25.40 cm)

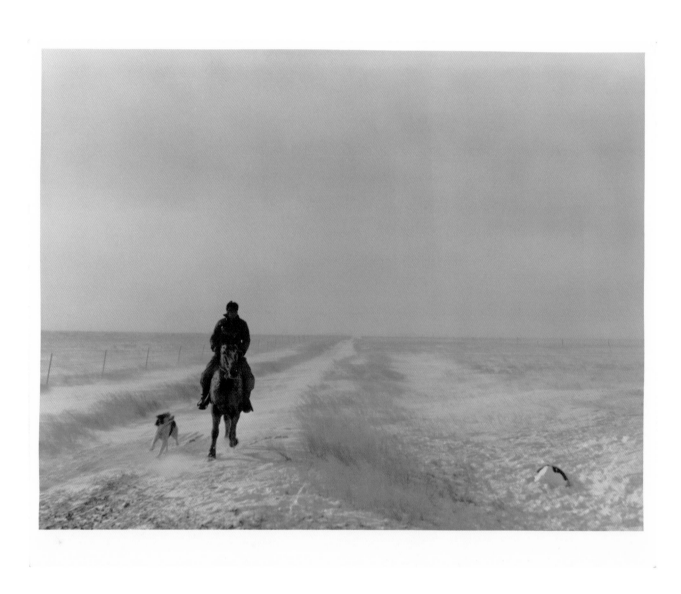

John Vachon, *Riding out to bring back the cattle. First stages of snow blizzard, Lyman County, South Dakota,* 1940.
Gelatin silver print, 8 x 10 in. (20.32 x 25.40 cm)

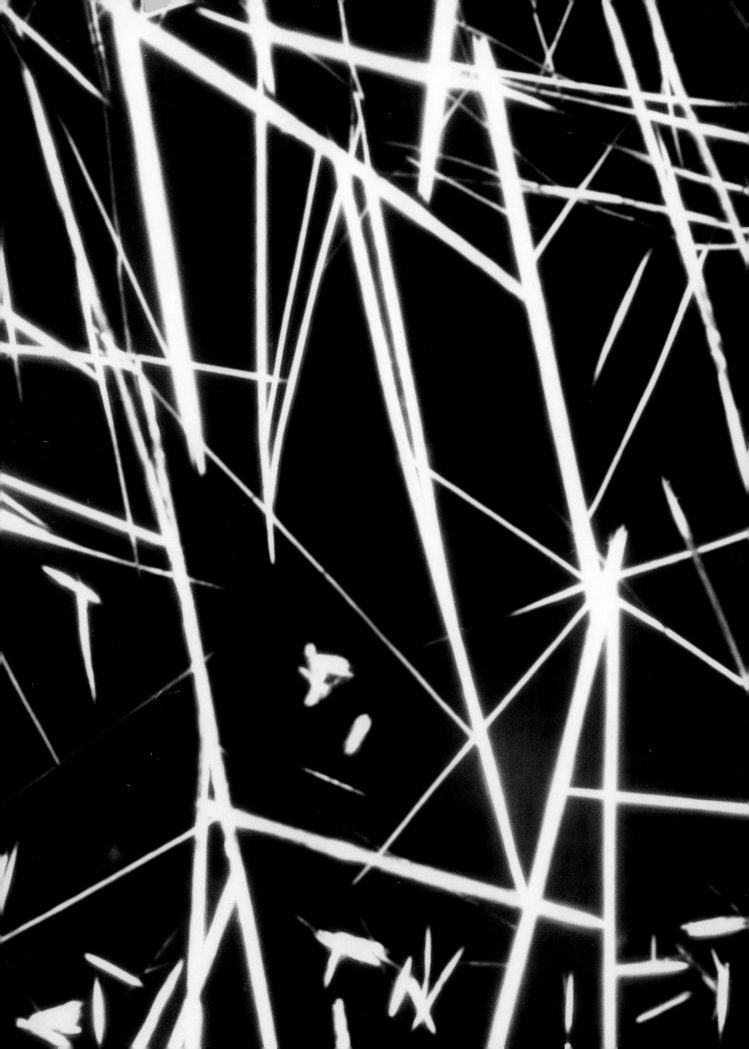

OBJECTS TRANSFORMED

By Annie Bourneuf and Vanessa Rocco

In the years between the First and Second World Wars, modernist photographers with the most divergent concerns shared an interest in the camera's ability to transform the everyday object–to offer it up from unconventional perspectives, to make it fresh and unfamiliar. "Our perception of the world has withered away; what has remained is mere recognition," wrote the Russian literary critic Viktor Shklovsky in the early 1920s, voicing a complaint often heard during these years. Many in the Soviet avant-garde and far beyond responded by turning to photography as a crucial means to renew human perception.[1] By introducing a range of formal and technical devices meant to thwart "mere recognition," photographers in Europe and the United States sought to force their audiences to abandon their timeworn visual habits.

In Werner Feist's 1929 photograph *Water Tap on Bauhaus Wall, Dessau,* for example, the emphasis on the textures of the stucco wall and metal tap underscores their physical solidity, but, at the same time, the framing of the image stresses the tap's intangible shadow. This pairing of object and shadow serves as an emblem of the workings of photography itself: a technology that captures objects so that they may be abstracted, dematerialized, and made available for formal transformation. Feist's photograph shows how a photographer can reimagine the most ordinary objects of the world by changing them into surprising, tightly structured images.

Although all objects potentially offer this double aspect as tangible things in the world and compositional elements, photographers in the interwar years did not find them all equally interesting. Industrial machines, automobiles, examples of modern architecture, rows of identical mass-produced commodities–all seemed especially suitable subjects. *Machine Detail* (ca. 1930), attributed to Else Thalemann, provides surprisingly little information about this particular machine's use. Instead, the image creates a vivid impression of metallic whirr and disorienting scale, encouraging the viewer to see this machine as a pure icon of modernity: the machine as such, stripped of context.

The fascination exercised by the machine and the factory assembly line on the imagination of so many photographers of the 1920s and '30s was heavily subsidized by industry itself. Many of the photographs of industrial subjects that are now exhibited and collected as artworks were originally commissioned by businesses as publicity images. Piet Zwart, for instance, a Dutch typographer, architect, and graphic designer, came to photography through his commercial design work: he initially

used photographs taken by others in his advertisements, combining them to create photomontages in the manner of El Lissitzky or László Moholy-Nagy. In 1929, he began taking photographs himself to serve as elements in his montages. He bought a view camera, set up a darkroom, and began to photograph arrangements of objects–cigarettes, mirrors, darkroom equipment, plates, forks, knives–whatever was handy and formally or texturally interesting.

Zwart felt that these practical experiments would enable him to discover the particular qualities of photographic vision as distinguished from human seeing. "The eye of the camera," Zwart asserted, "has different qualities from the human eye; the whole purpose is to exploit that difference to the full."[2] Like other exponents of New Vision photography, he prized the freedom to choose nearly any camera viewpoint, and the photograph's ability to capture and isolate unnoticed texture and detail.[3] For Zwart, this "photographic vision" was a means of modernizing human vision, of adjusting it to the new technological forms of the age. As such, it was inherently progressive: "Photographic vision is more generalized, more collective than the individual vision encountered in painting. Herein lies its significance for the future," he asserted in a 1930 article.[4]

Zwart's photograph *Stack of Doors* (1931) was taken in the warehouse of one of his commercial clients, the Bruynzeel door and flooring company in Zaandam. In 1931, Zwart took more than 150 photographs of the Bruynzeel factory for a mural-size photomontage to hang in the factory cafeteria. Zwart's montage incorporated dozens of his photographs of stacked planks, smokestacks, and workers operating machines. *Stack of Doors* shows the company's products waiting to be shipped out. The height of the towering stacks, the irregular arrangement of

identical doors, and the formal similarity between the pattern of the corrugated ceiling and that of the stacked doors are all emphasized by Zwart's viewpoint and framing, lending a dynamic quality to what could have been a straightforward document.

The growing demand from magazines for alluring photographs that could be used to advertise all sorts of consumer goods spurred the development of a modernist photographic style of still-life imagery. Jaromír Funke's *Vera Violetta Perfume* was taken for a 1930s advertisement for a perfume manufactured by the French firm Roger & Gallet. Funke, like Jaroslav Rössler, Josef Sudek, and others in the Czech avant-garde, regularly carried out advertising assignments from the late 1920s through the 1930s.[5] In his advertising work, he adapted for commercial use the approach to still-life photography that he had previously developed. Funke's still lifes of the mid-1920s–dramatically lit images of bottles, glass cubes, and spheres–grapple with the issues of illusionism, abstraction, and spatial ambiguity raised by modernist painting. The motif of a bottle casting a shadow on a slightly curved piece of paper that Funke employs in the Vera Violetta ad appears frequently in these earlier still lifes. In those photographs, however, single objects are not emphasized but rather dissolved into the overall patterning of the picture. With *Vera Violetta Perfume*, Funke focuses the composition on one particular and recognizable object, the perfume bottle. While echoing some of the devices of his earlier still-life photographs, he has redirected the main visual effect to suit the change of purpose.

To make studio shots of unprepossessing goods interesting enough to capture the gaze of potential buyers was no easy task. *"Bily" Shoes* (ca. 1930s), by Pere Català Pic, is a meticulously assembled advertising photomontage. Català was a prominent com-

mercial photographer in Barcelona during the 1930s, an era when Spanish artists, writers, and photographers were rapidly absorbing and adapting innovations of modernist photography from Europe, the United States, and the Soviet Union.[6] For Català, the process of putting together a photomontage–the carefully planned construction of an image out of component parts–served as a model for the modern photographer's work. "The photographer of our time and of the future," he wrote, "will no longer leave the house burdened by a camera and twelve plates to make portraits of things that look nice on his way. . . . Our photographer will project in his mind the photograph to be taken, he will sketch those components that it ought to include, just like an architect; he will resolve the technical difficulties, the possibilities of the elements at his disposal, and, finally, he will carry out his work."[7]

Català saw photomontage as one of the techniques by which a photographer could manipulate the photographic image and thereby give it the status of subjective expression. Unsurprisingly, the photographers he most admired were Man Ray, Maurice Tabard, and Moholy-Nagy. His own montaged advertising photographs smooth out the boundaries of the component images rather than playing on their disjunctions. *"Bily" Shoes* presents an improbable vision of a shoe with see-through soles in a bizarre yet spatially coherent image.

The activities of Zwart, Funke, and Català might lead one to view the photographic avant-garde between the wars as the research and development branch, unwitting or otherwise, of the commercial mass media. Many of the photographers of the period were no doubt happy to play this role, feeling that access to the mass media's vast scale of production and distribution could enable them to bring a "new optics" to the masses.[8] But this does not an-

swer the question of what avant-garde practices could mean in other contexts, when the usefulness of an object was less important than the aesthetic effect it could provide within an image.

One avant-garde strategy for circumventing the usefulness of an object was to turn to abstraction. In 1931, Raoul Hausmann, an early master of Berlin Dada photomontage, gave a lecture on the occasion of the exhibition *Fotomontage,* in Berlin. The exhibition had been organized by Cesar Domela, who was a member of the Ring "Neue Werbegestalter" (Circle of New Advertising Designers), a group attempting to introduce avant-garde visual forms such as photomontage into advertising images. In his talk, Hausmann pointed out the tensions inherent in this approach, conceding that the power of photomontage had been co-opted for both political and commercial ends. He concluded that "the business world has largely recognized the value of this propagandistic effect."[9]

Hausmann's lecture implied a degree of disillusion with the current applications of photomontage. In the same year, he produced a series of mysterious photographs entitled *Shadows*, one of which is part of the Daniel Cowin Collection. Hausmann used a piece of black paper or board into which holes had been cut in the form of a star and a chair with a caning seat; he then illuminated them with various light sources and photographed them, achieving a range of unusual visual effects. The typical result is a playful dance of dissolving white shapes on a rich, jet-black background. Although the star form remains legible, the overall impression is one of abstraction created by optical play. To judge by his *Fotomontage* lecture, it seems that Hausmann wanted to reach beyond the parameters of the photomontage work for which he was known and into realms that might be more resistant to commercial appropriation.

The German photographer Carl Strüwe, on the other hand, does not seem to have entertained hopes of resistance for his abstracted microphotographs. A graphic designer by profession, Strüwe embarked on his microphotographic series as an amateur undertaking, visiting research laboratories to view slides and to photograph the specimens he found most striking. The project continued from the mid-1920s to the 1950s, culminating in the publication of his 1955 book *Formen des Mikrokosmos* (Forms of the Microcosmos). Three of Strüwe's photographs are included in the present exhibition, and offer greatly magnified views of human bone, coffee beans, and acid crystals.

Microphotography and other forms of science photography–X-ray, astronomical, and infrared imagery–were widely disseminated in the 1920s. Such photographs played an important role in groundbreaking German exhibitions of the 1920s that mixed art photography and science photography, including the *Deutsche Photographische Ausstellung* in Frankfurt (1926), *Fotographie der Gegenwart* in Essen (1929), and *Film und Foto* in Stuttgart (1929).[10] But Strüwe did not place his exercises in the broader context of New Vision photography, with its aim of transforming vision. Instead, he seems to have regarded his photographs as more or less self-contained art objects. Although Strüwe's images seem to make reference to avant-garde explorations of geometric or biomorphic abstraction, the allegorical titles he gave to his works often point in more conventional directions–*Primary Image of Individuality*, or *Primary Image of the Urge for Freedom*.

These photographs of transformed objects reflect a variety of artistic intentions from subversive to retrograde. The more provocative of these works can still force us to reexamine the everyday objects that we take for granted and to see them in new ways.

1 Quoted in Christopher Phillips, "Resurrecting Vision: The New Photography in Europe between the Wars," in Maria Morris Hambourg and Christopher Phillips, *The New Vision: Photography between the World Wars* (New York: The Metropolitan Museum of Art, 1989), 83.

2 Piet Zwart, quoted in J. Kasender, "Fotografie, typographie, reclame: Gesprek met architect Piet Zwart," translated and reprinted in *Piet Zwart, 1885-1977* (Amsterdam: Focus Publishing, 2000), 161.

3 Zwart, quoted in ibid., 161-63.

4 Zwart, "Fotovisie," *Wereldkroniek*, December 20, 1930, translated and reprinted in ibid., 159.

5 Jan Mlčoch, "Avant-Garde Photography and Advertising," in *Czech Photographic Avant-Garde: 1918–1948*, ed. Vladimir Birgus (Cambridge: MIT Press, 2002), 162.

6 Biographical information about Pere Català Pic is available in *Les Avantguardes fotogràfiques a Espanya, 1925-1945,* exhibition catalogue (Barcelona: Fundació "La Caixa," 1998), 203-04; and *Idas y Caos: Trends in Spanish Photography 1920-1945,* exhibition catalogue (New York: International Center of Photography, 1985), 211.

7 Pere Català Pic, "The Modern Photographic Revolution," *Mirador*, December 22, 1932, translated and reprinted in *Idas y Caos*, 200. We have slightly altered the punctuation to accord with standard American usage.

8 For a discussion of how Zwart and other members of the Ring "Neue Werbegestalter" came to see advertising and the mass media as politically progressive, see Maud Lavin, "For Love, Modernism, or Money: Kurt Schwitters and the Circle of New Advertising Designers," in Maud Lavin, *Clean New World: Culture, Politics, and Graphic Design* (Cambridge, MA: MIT Press, 2001).

9 Raoul Haussmann, "Fotomontage," in *a bis z* (Cologne) (May 1931), translated in Christopher Phillips, *Photography in the Modern Era: European Documents and Critical Writings*, 1913-1940 (New York: Metropolitan Museum of Art/Aperture, 1989), 178-80. Hausmann goes on to surmise: "The necessity for clarity in political and commercial slogans will influence photomontage to abandon more and more its initial individualistic playfulness.", 180.

10 Oliver Botar's unpublished dissertation contains useful discussions of the relation between art and scientific material, as evidenced in these two exhibitions, among others. See Oliver Botar, *Prolegomena to the Study of Biomorphic Modernism: Biocentrism in Moholy-Nagy's New Vision and Kallai's Bioromantik* (Ph.D. diss., University of Toronto, 1998).

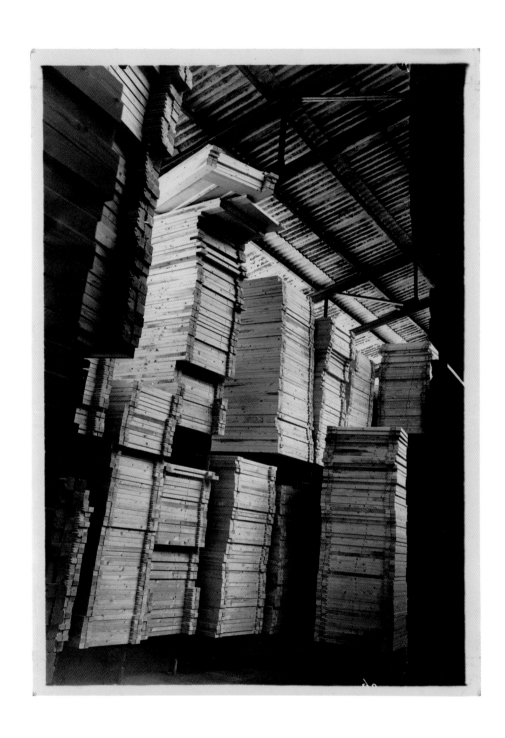

Piet Zwart, *Stack of Doors,* 1931.
Gelatin silver print, 6 7/8 x 4 3/4 in. (17.46 x 12.07 cm)

Attributed to Else Thalemann, *Machine Detail,* ca. 1930.
Gelatin silver print, 6 5/8 x 8 3/4 in. (16.83 x 22.23 cm)

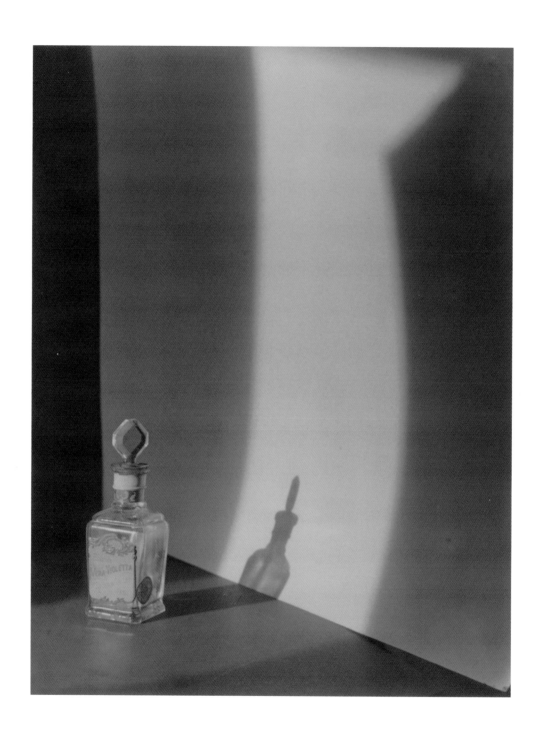

Jaromír Funke, *Vera Violetta Perfume,* ca. 1930s.
Gelatin silver print, 11 5/8 x 9 1/4 in. (29.53 x 23.50 cm)

Harold Halliday Costain, *Eel-Skid Oil,* ca. 1936.
Gelatin silver print, 14 x 11 in. (35.56 x 27.94 cm)

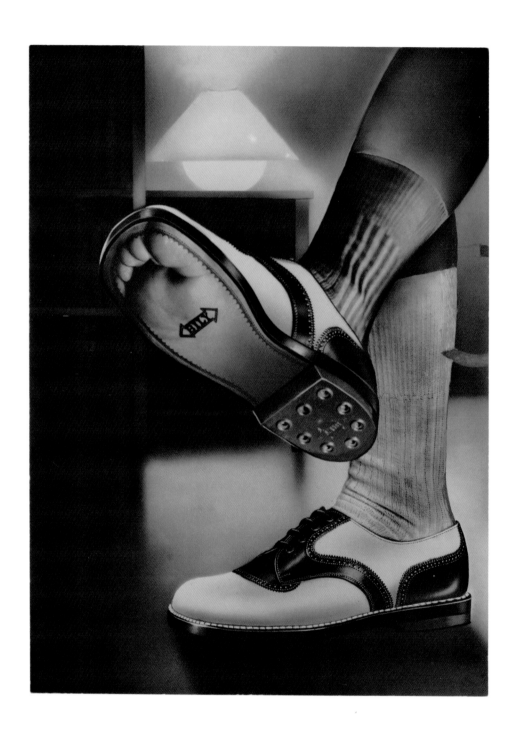

Pere Català Pic, *"Bily" Shoes,* ca. 1930s.
Gelatin silver print, 10 15/16 x 8 in. (27.79 x 20.32 cm)

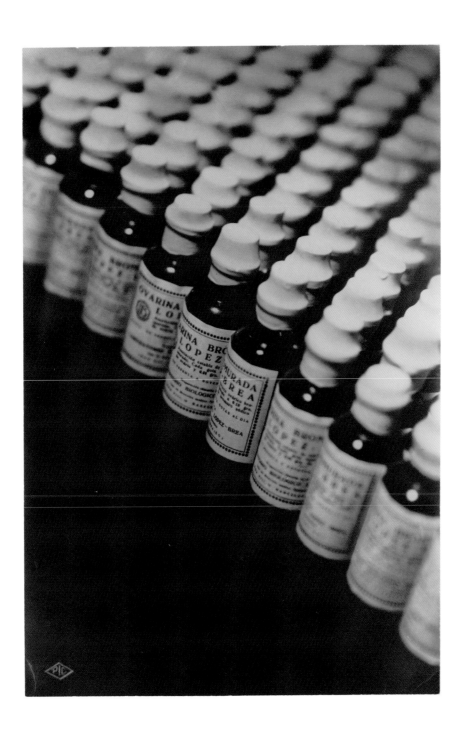

Pere Català Pic, *Ovarina,* ca. 1930s,
Gelatin silver print, 11 5/16 x 7 1/2 in. (28.73 x 19.05 cm)

Niels Laugesen, *Automobile* [Humber Auto], ca. 1920s or '30s.
Gelatin silver print, 9 1/8 x 6 11/16 in. (23.18 x 16.99 cm)

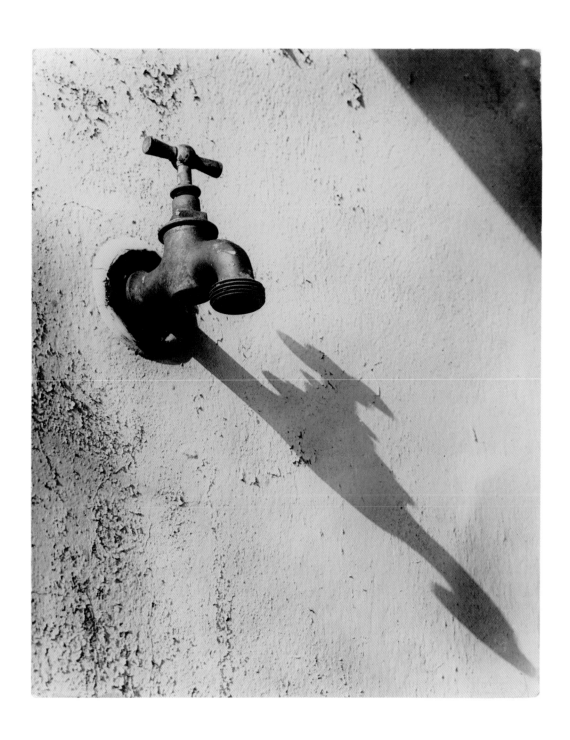

Werner David Feist, *Water Tap on Bauhaus Wall, Dessau,* 1929.
Gelatin silver print, 7 1/8 x 5 3/4 in. (18.10 x 14.61 cm)

Jósef Antoni Kuczyński, *Still life* [pitcher and fruit], 1925.
Platinum print, 8 5/8 x 11 in. (21.91 x 27.94 cm)

Wynn Richards (Martha Wynn), *Colander and Spoons,* ca. 1918.
Gelatin silver print, 8 1/8 x 6 1/8 in. (20.64 x 15.56 cm)

Edmund Teske, *Tijuana, Mexico,* ca. 1959.
Gelatin silver print, 7 1/16 x 4 7/8 in. (17.94 x 12.38 cm)

Gordon Parks, *Contents of an army supper K-Ration Unit, used by soldiers on the fighting front,* 1945.
Gelatin silver print, 7 5/8 x 9 5/8 in. (19.37 x 24.45 cm)

Walter Tralau, *Assignment for László Moholy-Nagy's Preliminary Course at the Bauhaus,* ca. 1926-27.
Gelatin silver print, 4 1/8 x 3 in. (10.48 x 7.62 cm)

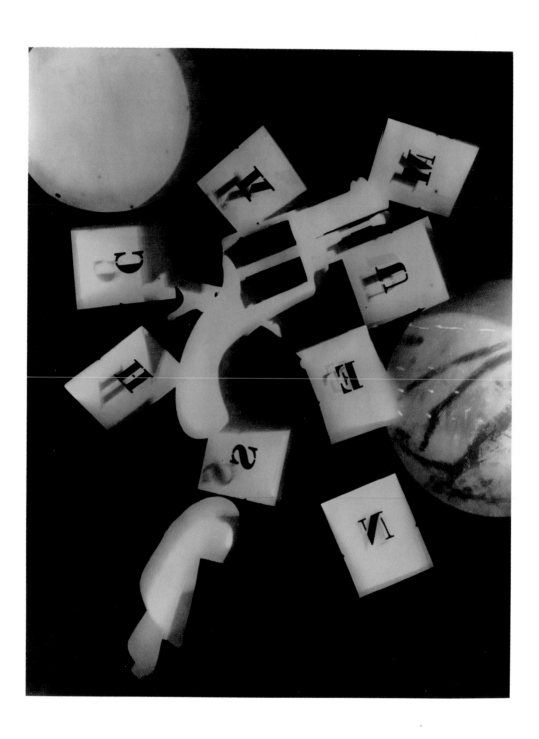

Man Ray, *Untitled* [Rayograph], 1924.
Gelatin silver print, 10 3/4 x 8 1/2 in. (27.31 x 21.59 cm)

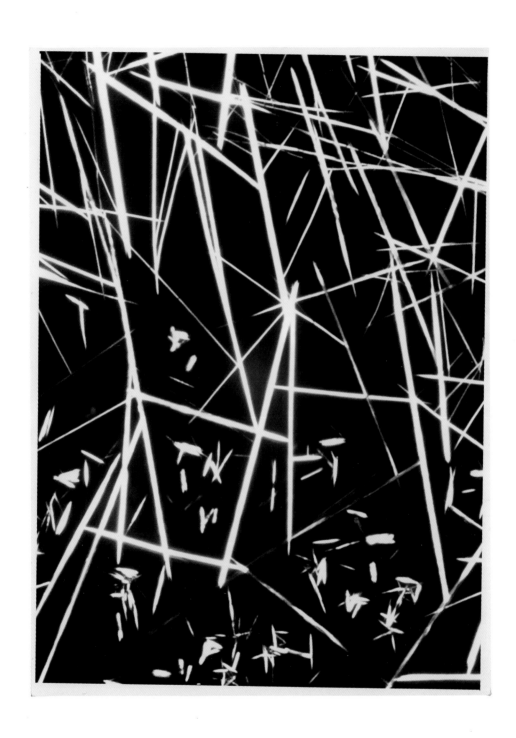

Carl Strüwe, *Straight Lines: Crystal of Coffea Arabica,* n.d.
Gelatin silver print, 9 1/4 x 6 7/8 in. (23.50 x 17.46 cm)

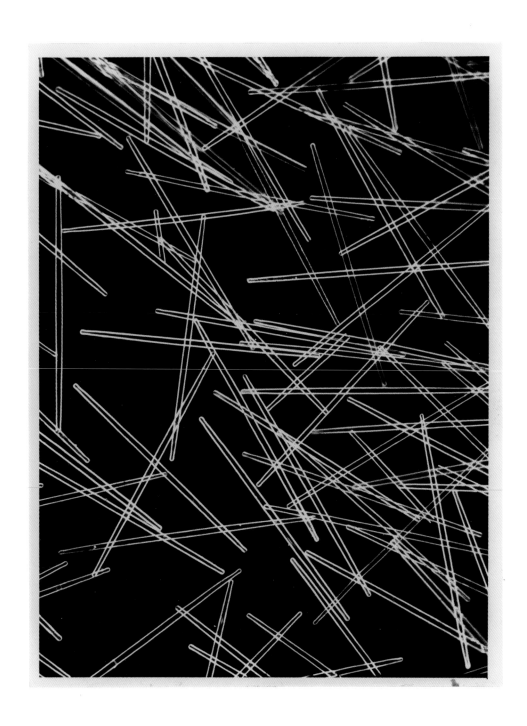

Carl Strüwe, *Needles as Life-form of the Diatom "Synedra danica,"* 1929.
Gelatin silver print, 9 1/16 x 6 13/16 in. (23.02 x 17.30 cm)

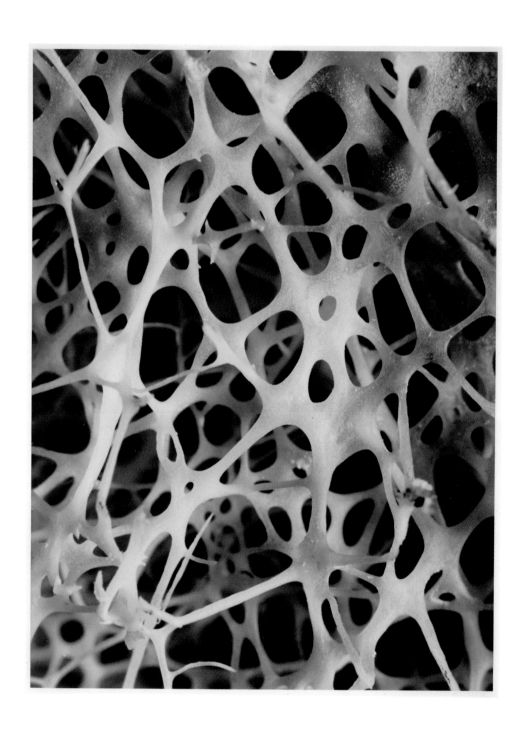

Carl Strüwe, *Structure of a Human Bone,* n.d.
Gelatin silver print, 15 3/4 x 11 13/16 in. (40 x 30 cm)

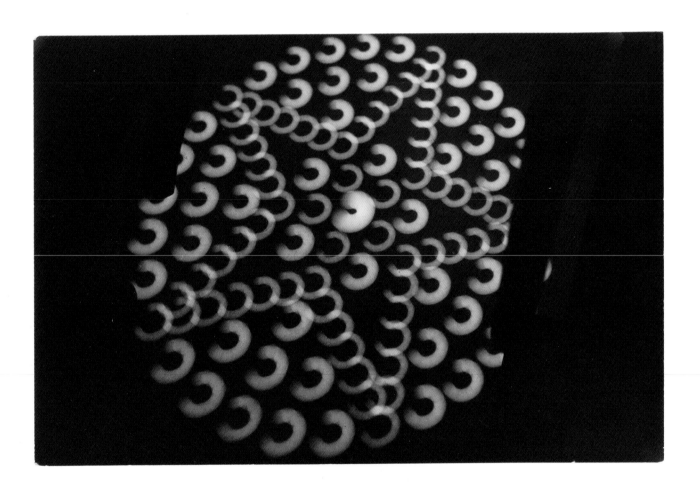

Raoul Hausmann, *Untitled* [from the "Shadows" series], 1931.
Gelatin silver print, 7 3/4 x 11 3/4 in. (19.69 x 29.85 cm)

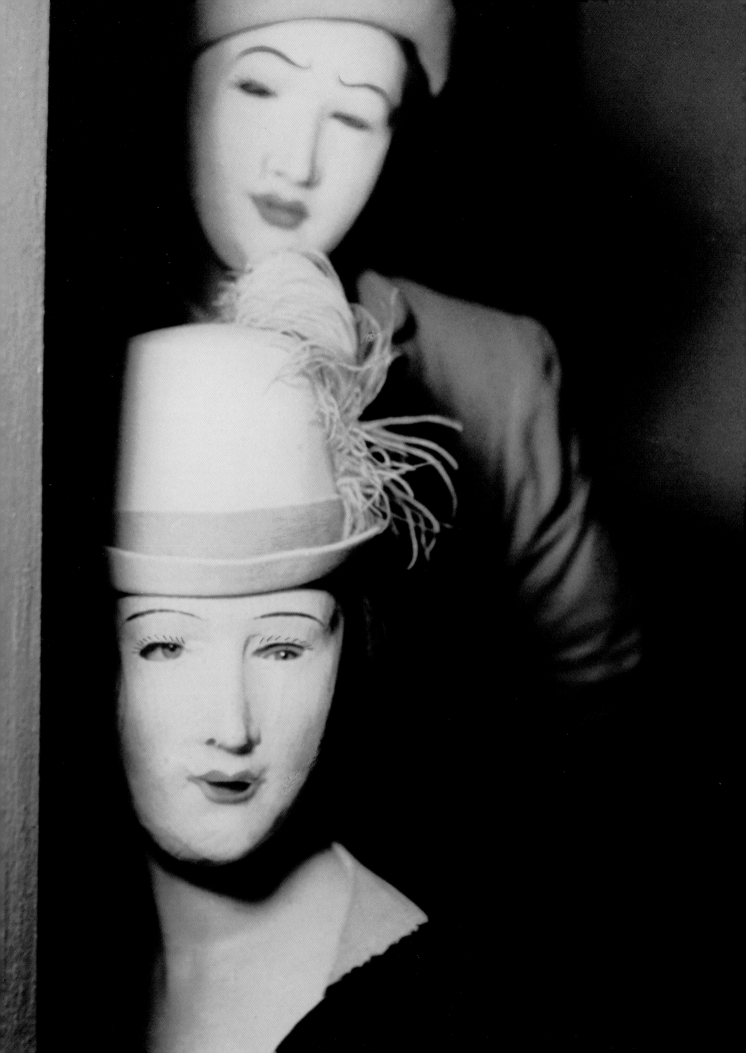

FACES, BODIES, SURREALIST IDENTITIES

By Vanessa Rocco

One of the primary themes of twentieth-century modernism is that of liberation: liberation from nineteenth-century moralities, from social and psychological constraints, from conventional modes of expression. The Surrealists, in particular, flagrantly promoted the "unexpected" precisely to subvert established bourgeois behaviors and art practices. The movement's founder, the French poet André Breton, railed against the straightjacket of "objective reason"[1] and in the first of his Surrealist manifestoes (1924) announced: "The mere word 'freedom' is the only one that still excites me . . . imagination alone intimates what might be."[2] The liberatory aspects of the Surrealist enterprise drew artists of different nationalities to Paris in the 1920s and early '30s. They brought a variety of avant-garde influences from their own countries, as well as novel strategies to reanimate art and to break free of tired idioms.

A key aspect of Surrealist experimentation was the probing of the unconscious mind. Reconfigurations of identity and the body were consequently favorite visual tropes of the Surrealist movement. Unsettling and jarring representations of the human form fascinated Breton and the Surrealist visual artists, including the principal Surrealist photographer, Man Ray. The use of dolls and doppelgängers, fantasies and dream states–all grew out of the Surrealist interest in Freudian analysis and the exploration of the unconscious. Although photography was a medium of lesser importance to Breton than literature and painting, the photographic experiments of Man Ray and others resulted in some of the most powerful Surrealist imagery due to the strange appearances of the human body.[3]

The German artist Hans Bellmer took a three-month trip to Paris in late 1924, the year Breton published the Surrealist manifesto. This trip likely influenced Bellmer's famous doll photographs of the 1930s, as he became familiar with the ideas of the Surrealists and met Giorgio De Chirico, who often used images of mannequins in his disquieting paintings. But the photographs were also the result of myriad local influences in Berlin. These included Bellmer's receipt of a box of childhood toys, sent to him by his mother after his father's death; his witnessing of the opera *The Tales of Hoffmann*, which includes the story of a man who falls in love with a doll; and his retreat from commercial work to his studio after the Nazi seizure of power in 1933.[4] The doll as photographic subject became a stand-in for Bellmer himself, as well as the repository for his childhood demons and adult anxieties. This was made clear in his prose poem "The Father" (1936), in

which he wove a tale of himself and his brother Fritz pretending to be little girls to spite their brutish and tyrannical father, an eventual Nazi Party member.

Bellmer's first doll sculpture was constructed in 1933, and his photographs of it were published in his 1934 book *Die Puppe* (The Doll). The second doll was constructed in 1935, and photographs of it appeared in Bellmer's 1949 book *Les Jeux de la poupée* (Games of the Doll).[5] The first doll is shown in one photograph from the Daniel Cowin Collection as a skeletal frame seated in a chair, eerily lacking a full bodily armature. In most other photographs, we see this doll sculpted out of plaster; it is arranged in a variety of poses, both prone and standing, and often with limbs missing. The second doll, seen in a photograph from 1935, is also shown in a deconstructed state, with its central ball joint and other parts strewn about on a bare, stained floor. Bellmer photographed this second doll in dozens of costumes and poses in order to comment on everything from political repression to gender mobility in interwar Germany. In both of these photographs, however, he has freed himself from any literal representation of the human body, instead paring down the human form and taking it apart in an aggressive, almost violent manner.

Another German, Werner Rohde, had a background in Neue Sachlichkeit photography, having studied with Hans Finsler starting in 1926. But Rohde had a more playful side than his teacher, whose extreme close-ups of objects and materials were characterized by a thoroughgoing sobriety. In 1927, Rohde met László Moholy-Nagy, who was preparing the second edition of his *Malerei Photographie Film* (Painting Photography Film).[6] In this seminal modernist treatise, Moholy espoused all forms of experimental, "New Vision" photography that could expand the perception of the viewer: these included photograms, double exposures, negative images, and photomontage.

Moholy was one of the principal organizers of the important 1929 exhibition *Film und Foto* in Stuttgart, where New Vision, Neue Sachlichkeit, and Surrealist photographs were all mixed together. The exhibition included Rohde's disturbing *Karneval,* a photograph of a lipsticked mask that echoes the mask and clown motifs Rohde often used during this period. Closely related to this image is Rohde's *Pit and Renata* (ca. 1933). "Pit" may refer to the pseudonym of Ellen Auerbach, a former Bauhaus student who founded the advertising photo studio "ringl + pit" with Greta Stern; Renata was Rohde's model and future wife, Renata Bracksieck. Rohde's use of theatrical masks in these works is similar to Bellmer's use of the doll as doppelgänger in that both elicit a sense of the uncanny–Freud's term for something that is simultaneously familiar and strange.[7]

The impact of Freud's theories was felt on both sides of the Atlantic. The American photographer Edmund Teske was an avid reader of Freud, and, beginning in the early 1930s, he was also influenced by the Surrealistic darkroom manipulations of Man Ray. In 1937, the year that Teske began teaching at Moholy's New Bauhaus in Chicago, he began a series of images called "Portraits of My City." He rode streetcars and photographed passersby, buildings, and glass-windowed storefronts that reflected the city's architecture. In *Mannequins, Chicago* (1938), Teske evoked the uncanny through a clever use of mannequins and doubles. The unsettling, staring faces, the headless torso, and the amusing gesture of the outstretched hand covering the absent genitals all attest to Teske's grasp of Surrealist subject matter. In 1939, Teske began working with Berenice

Abbott in her New York studio, and was introduced to her collection of Eugene Atget's street views of Paris, including his storefront photographs from the early twentieth century. Teske's exposure to Atget's imagery inspired him to continue with the "Portraits of My City" series throughout his life.

A more subtle example of Freud's influence was the motif of the *implied* double in Surrealist-inspired photography, achieved through superimposition, the use of mirrors, or the presentation of fragments of the human figure. The Czech photographer Jaroslav Rössler often used the technique of superimposition, as seen in the work from the Daniel Cowin Collection included in the present exhibition. Rössler spent almost a decade in Paris, from 1927 to '35, during the heyday of Surrealism, and his work synthesized various influences, including that of his mentor, the master Czech photomontagist and avant-garde theorist Karel Teige. In this photograph, the figure of the elegantly dressed woman floats over what appears to be a close-up of her own face, as if she is a vestige of her own imagination. The resultant doubling suggests the Surrealist impulse to dissolve the barrier between body and mind.

Herbert List was a German whose photographs in the early 1930s began to draw on the motifs of Surrealism, especially in his use of masks. List, half-Jewish, chose in 1936 to move to London, then Paris, as the Nazi regime became more oppressive. These cities held major Surrealist exhibitions from 1936 to '38, and List's work continued to be stimulated by the Surrealist photographers' use of uncanny doppelgängers and phantomlike double exposures, as well as the use of mirrors. List also admired Atget's haunting photographs of shop window displays and mannequins, which were widely disseminated in Germany in the early 1930s.[8] List's *Plate Glass* (ca. 1936) is a disorienting visual experience that turns on the viewer's gradual realization that the depicted mirrors are propped in front of a shop, where they reflect street lamps and ghostly passersby. The print itself is a trompe l'oeil of sorts–the paper around the mirrors has been cut away so that the photograph is no longer a square but an irregular shape determined by the undulating lines of the mirrors.

The American Francis Bruguière was primarily interested in the use of light effects in his photographs. After photographing his friend Thomas Wilfred's light-display machine, he experimented with photographs of his own cut-paper compositions as illuminated by various lighting arrangements. Although Bruguière called these works abstractions, many clearly suggest human forms. In *Cut Paper Abstraction* (1927), there is a discernible profile, a body, and what appears to be a thumb being sucked. The suggestion of a human form is uncanny and unsettling, particularly since the scissor cuts in the head also evoke a sense of violence.[9] Bruguière created several similar works for the book *Beyond This Point* (1929), a pseudo-philosophical prose collaboration with British journalist Lance Sieverking.[10]

Evocations of fantasies and dream states abound in the artworks associated with Surrealism. Ilse Bing was a Paris-based German photographer who successfully melded New Vision approaches with Surrealist techniques such as solarization, a darkroom procedure that creates tone reversals and ghostly outlines around depicted objects. For an advertising campaign promoting the fashion designer Elsa Schiaparelli's perfume "Lily," Bing produced a solarized photograph of a beautiful woman who appears to be euphorically floating in a sea of lilies. The woman's pose and hair echo the forms of the lilies. Bing referred to her use of objects in unexpected ways as *dépaysement*, a term signifying their removal from their customary environments.[11]

Outside of France, Surrealism was often absorbed by photographers within the context of prevailing local styles. In Poland, for example, Surrealist imagery was mediated by a lingering adherence to Pictorialism and its attempts to mimic the tactile effects of nineteenth-century painting.[12] The Polish photographer Henryk Hermanowicz began working in a Pictorialist vein in 1927, but his mesmerizing *Woman with Closed Eyes* (1937) updates the sensuality of Pictorialism by hinting at the Surrealist fascination with the unconscious. The woman portrayed in this photograph seems to be suspended in a dream state, and to have turned her gaze from the realities of the everyday world to the interior realm of the imagination. Such images suggest how pervasive the influence of the Surrealist movement was, and how widely the repercussions of modernist photography were felt by the late 1930s. Awareness of such overlooked artists as Hermanowicz can yield new insights into the ways that modernist principles were spread and adapted to local circumstances.

1 Andre Breton, "Manifesto of Surrealism," in *Manifestoes of Surrealism*, trans. Richard Seaver and Helen R. Lane (Ann Arbor: University of Michigan Press, 1969), 8.

2 Ibid., 4.

3 See Rosalind Krauss, "Photography in the Service of Surrealism," in Rosalind Krauss and Jane Livingston, eds., *L'Amour Fou: Photography and Surrealism* (New York: Abbeville Press, 1985), 15-42.

4 Therese Lichtenstein discusses Bellmer's abandonment of commercial work as a form of resistance against Nazi rule. See Therese Lichtenstein, *Behind Closed Doors: The Art of Hans Bellmer* (Berkeley: University of California Press, and New York: International Center of Photography, 2001), 5.

5 Most of the photographs included in *Les jeux de la poupée* were taken between 1935 and 1938. I would like to thank Adam Boxer for showing me several variants of the Bellmer works in the Daniel Cowin Collection that are in the holdings of Ubu Gallery.

6 *Malerei Photographie Film* was actively discussed in Rohde's art school classes in Halle starting in 1925, when the first edition was published. Ingo Taubhorn and Ferdinand Brüggemann, *Werner Rohde: Fotografien 1925-27* (Berlin: Serie Folkwang, 1992), 16.

7 Sigmund Freud, "The Uncanny," vol. 17, *The Complete Psychological Works of Sigmund Freud*, trans. and ed. James Strachey (London: Hogarth Press, 1953-73).

8 *Eugene Atget: Lichtbilder* was published in Germany in 1930.

9 Bruguière seems to have arrived at the angular cuts of paper through the German Expressionist shapes of his theater designs. His biographer, James Enyeart, claims that his "surrealism" developed independently of knowledge of the movement, but that when he later moved to Europe he followed Man Ray's experiments avidly. James Enyeart, *Bruguière: His Photographs and His Life* (New York: Alfred A. Knopf, 1977), 32.

10 Bruguière was criticized by his friend, the critic Sadakichi Hartmann, for other photographs in the book that combined multiple-exposed human faces with the cut-paper abstractions. Hartmann also complained that it pained him to feel "the knife" too much. He preferred the pure abstractions. See letter to Bruguière dated December 31, 1931, cited in Enyeart, *Bruguière*, 7, no. 50.

11 Ilse Bing, quoted in Nancy C. Barrett, *Ilse Bing: Three Decades of Photography*, exhibition catalogue (New Orleans: New Orleans Museum of Art, 1985), 25.

12 For a discussion of the tension between lingering Pictorialism and the burgeoning New Photography in the early twentieth century, see Vanessa Rocco, *Before Film und Foto: Pictorialism to the New Vision in German Photography Exhibitions, 1909-29* (Ph.D. diss., New York: Graduate Center, CUNY, 2004).

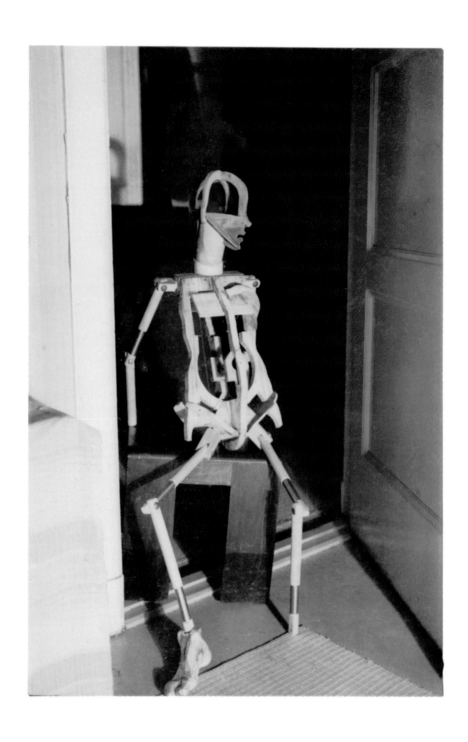

Hans Bellmer, *The Doll,* 1934.
Gelatin silver print, 4 3/8 x 3 in. (11.11 x 7.62 cm)

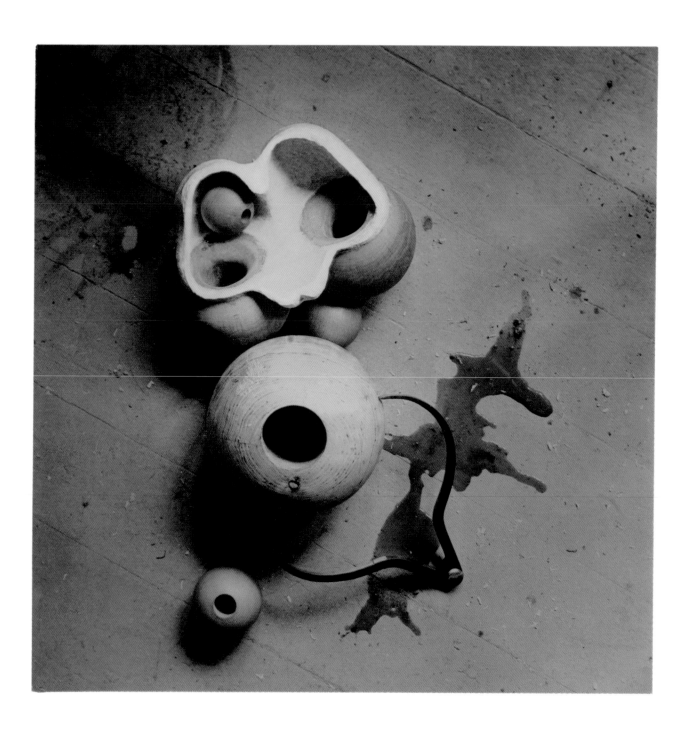

Hans Bellmer, *The Doll,* 1935.
Hand-colored gelatin silver print, 5 1/2 x 5 1/2 in. (13.97 x 13.97 cm)

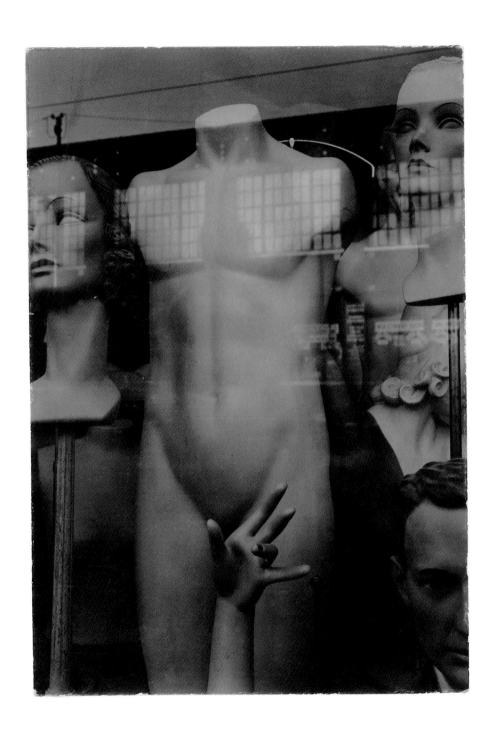

Edmund Teske, *Mannequins, Chicago,* 1938.
Gelatin silver print, 9 11/16 x 7 7/16 in. (24.61 x 18.89 cm)

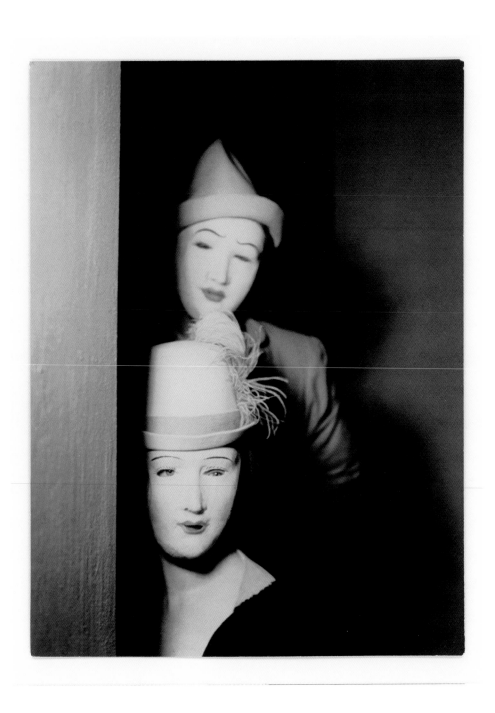

Werner Rohde, *Pit and Renata*, ca. 1933.
Gelatin silver print, 8 3/4 x 6 1/2 in. (22.23 x 16.51 cm)

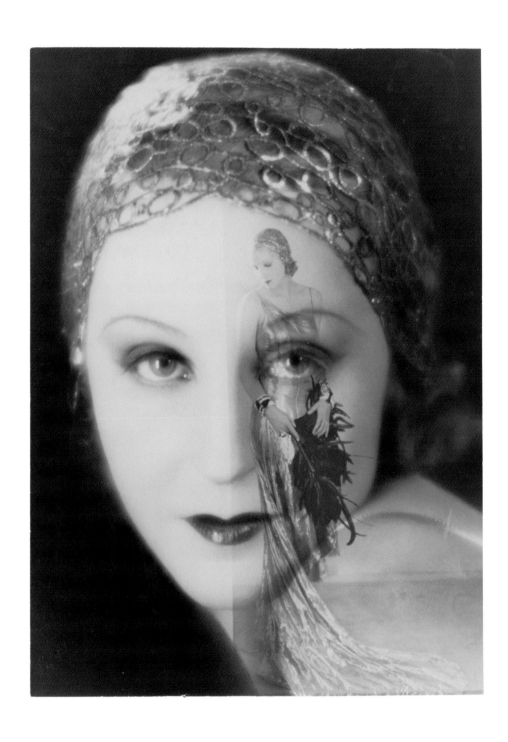

Jaroslav Rössler, *Untitled* [double exposure of woman's face and woman in evening gown], 1933.
Gelatin silver print, 10 3/4 x 7 3/4 in. (27.31 x 19.69 cm)

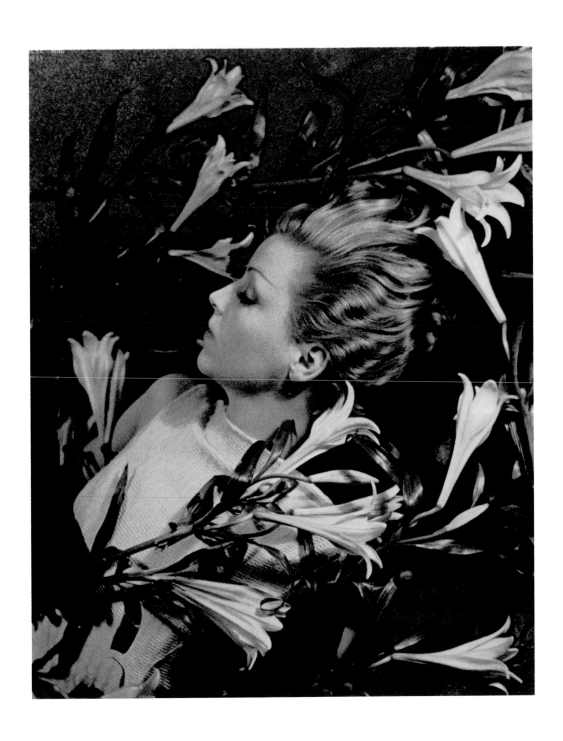

Ilse Bing, *Study for "Salut de Schiaparelli" (Lily Perfume),* 1934.
Gelatin silver print, 19 x 15 1/4 in. (48.26 x 38.74 cm)

Herbert List, *Plate Glass,* ca. 1936.
Gelatin silver print, 11 x 9 1/2 in. (27.94 x 24.13 cm)

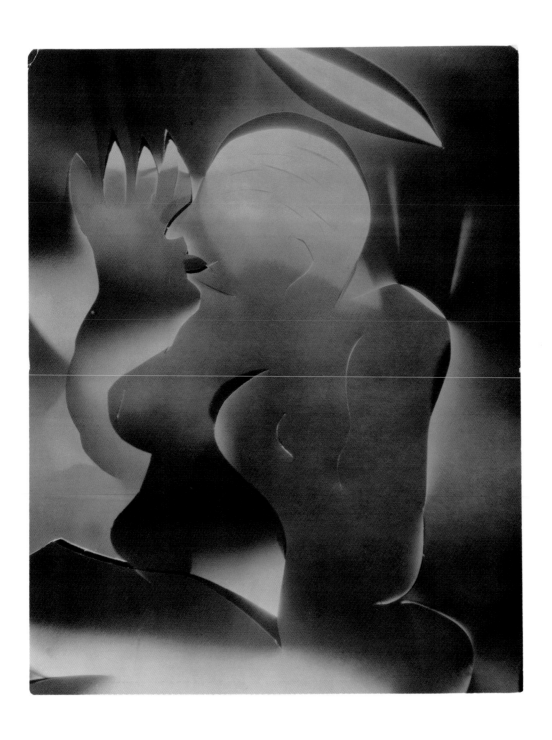

Francis Bruguière, *Cut Paper Abstraction,* ca. 1927.
Gelatin silver print, 9 1/4 x 7 1/4 in. (23.5 x 18.42 cm)

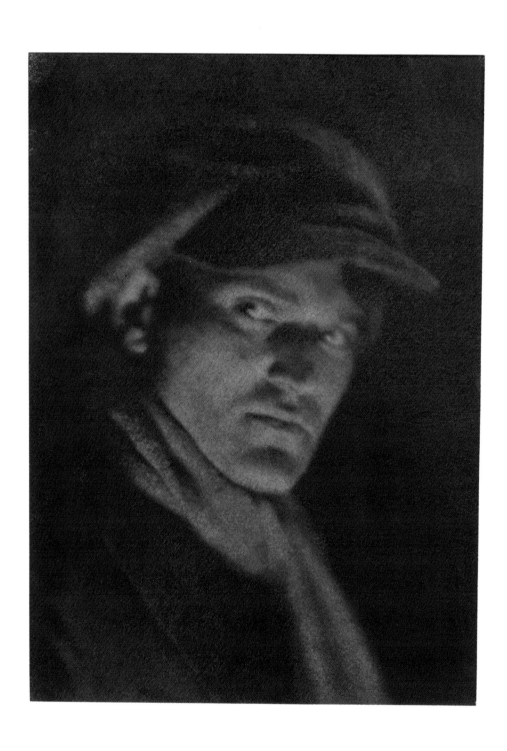

Jósef Antoni Kuczyński, *Untitled* [portrait of a man], ca. 1920s.
Gum-bichromate print, 11 3/4 x 8 1/2 in. (29.85 x 21.59 cm)

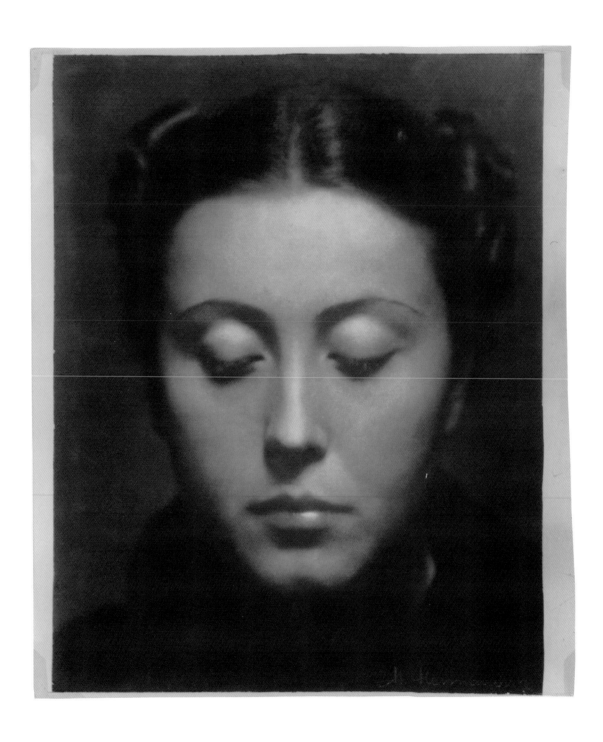

Henryk Hermanowicz, *Woman with Closed Eyes,* 1937.
Gelatin silver print, 11 3/4 x 9 3/8 in. (29.85 x 23.81 cm)

105

BIOGRAPHIES

BERENICE ABBOTT
(American, 1898–1991)

Born in Springfield, Ohio, Berenice Abbott spent the early part of her artistic career studying sculpture in New York, Berlin, and Paris, where she worked as Man Ray's studio assistant. This experience led her to photography, and in 1926 she established herself as an independent photographer whose portraits of well-known artists and writers rivaled those of Man Ray in excellence and renown. Through Man Ray, she met Eugène Atget, whose photographs of the transformation of Paris from the *ancien régime* through the mid-1920s impressed her with their methodical technique and intuitive inflections of artistry.

In 1929, Abbott returned to the United States, where she embarked on her best-known body of work–a documentation of New York City for which she developed her famous bird's-eye and worm's-eye points of view. She worked on the project independently through the early years of the Depression and in 1935 secured funding from the Federal Art Project, a part of the Works Progress Administration. Her pictures were published as *Changing New York* (1939), which was both critically and commercially successful; it remains a classic photographic publication.

Haaften, Julia Van. *Berenice Abbott, Photographer: A Modern Vision: A Selection of Photographs and Essays.* New York: New York Public Library, 1989.

Yochelson, Bonnie. *Berenice Abbott: Changing New York.* Exhibition catalogue. New York: Museum of the City of New York, 1997.

HANS BELLMER
(French, born in Katowice, Silesia [now in Poland], 1902–1975)

Hans Bellmer worked in coal mines before entering the Berlin Technische Hochschule to study engineering in 1923. There he studied perspective with George Grosz and established contact with Dada artists. From 1924 to 1936, he worked variously as a typographer and draftsman. He met members of the Surrealist group in 1924, on a trip to Paris. In 1932, he attended the opera *The Tales of Hoffmann* and became fascinated with one of the tales, *The Sandman,* which features a female doll.

In often violently erotic photographs and drawings, Bellmer developed the Surrealist theme of mannequins and dolls as metaphors of sexuality. Bellmer began constructing his first doll or "artificial girl" in 1933, with his brother, Fritz. Photographs of the doll were published by Bellmer at his own expense for the first edition of his book *Die Puppe.* A second series of dolls was created in 1935–38. Bellmer left Berlin in 1938 and settled in Paris, where he frequented Surrealist circles. With the outbreak of World War II, he was interned as a German citizen in a prison camp in 1939. Bellmer's later work appeared in numerous exhibitions, including the 1947 International Surrealist Exposition in Paris.

Lichtenstein, Therese. *Behind Closed Doors: The Art of Hans Bellmer.* New York: International Center of Photography, 2001.

Taylor, Sue. *Hans Bellmer: The Anatomy of Anxiety.* Cambridge, MA: MIT Press, 2000.

MIECZYSLAW BERMAN
(Polish, 1903–1975)

Born in Warsaw, Poland, Mieczyslaw Berman attended the Polish School of Decorative Art between 1921 and 1923, developing there an interest in Constructivist art. Inspired by artists of the period, Berman produced his first photomontage in 1927. His early compositions incorporated elements from the Soviet avant-garde, Bauhaus graphic design, and Dada photomontage. In the 1930s, Berman discovered the work of the German photomontagist John Heartfield, and his subsequent politically charged and satirical creations reflect this influence. When the German army invaded Poland in 1939, Berman fled to the Soviet Union for safety, and throughout the war he produced photomontages directed against Hitler and the Nazis. For the duration of his life, he continued to explore political subjects in his work, including the threat of atomic weapons, the persecution of Jews, the consequences of imperialism, and the conflict in Vietnam.

Mieczyslaw Berman. Wroclaw, Poland: Muzeum Narodowe we Wroclawiu, 1990.

ILSE BING
(American, born in Germany, 1899–1998)

Born in Frankfurt, Ilse Bing studied art history at Frankfurt University. She began to photograph in 1928 and in the spring of 1929 bought a Leica, which she would use for the next twenty years. In 1930 Bing moved to Paris. During the next decade she explored different genres, including architectural and interior photography

as well as advertising and editorial photography. She achieved great success, publishing in the leading French illustrated magazines and exhibiting alongside such figures as Man Ray, André Kertész, László Moholy-Nagy, and Henri Cartier-Bresson.

In 1940, at the outset of World War II, Bing and her husband, the pianist Konrad Wolff, were interned by the Vichy government as enemy aliens. A year later, they immigrated to New York. Bing took a seven-year hiatus from photography before returning to it in the late 1940s. She devoted the last period of her life primarily to writing poetry and making drawings and collages. Her photographic work was rediscovered after the Art Institute of Chicago included it in the exhibition *Photographs from the Julien Levy Collection* (1976). A number of publications and solo shows followed, including retrospectives at the New Orleans Museum of Art in 1985 and at the Musée Carnavalet in Paris in 1987.

Ilse Bing: Paris 1931-1952. Paris, Musée Carnavalet, 1987.

BRASSAÏ
(French, born in Brasov, Transylvania [now in Romania], 1899–1984)

Brassaï, born Gyula Halàsz in the town of Brasov, Transylvania, was known for depicting the eclectic nightlife of Paris in the 1930s. Originally intent on becoming a painter, he studied at the Academy of Fine Arts in Budapest in 1918 and the Akademische Hochschule in Berlin in 1921, before moving to Paris in 1924. While working as a journalist there, he met André Kertész, who encouraged him to take up photography. Brassaï embraced photography as a means to record his observations of Parisian streets, nightclubs, cafés, and brothels. His first book, *Paris de Nuit* (Paris by Night), won both critical and popular acclaim when published in 1932. Brassaï cultivated friendships with artists and writers, and although he was not a Surrealist, his photographs were highly regarded by the Surrealists, whose journal *Minotaure* published his work frequently.

Berman, Avis, Richard Howard, and Anne Wilkes Tucker. *Brassaï: The Eye of Paris.* Houston: Museum of Fine Arts, 1999.

Lionel-Marie, Annick, and Alain Sayag, eds. *Brassaï: The Monograph.* Boston: Bulfinch Press, 2000.

FRANCIS BRUGUIÈRE
(American, 1879–1945)

Born in San Francisco, Francis Brugière was a painter, musician, and photographer. A 1905 visit to New York and a subsequent meeting with Alfred Stieglitz spawned his initial interest in photography. By 1912 he had begun to develop an interest in abstraction and a system of multiple exposure. After moving to New York and opening a studio in 1918, Brugière photographed for *Vogue, Harper's Bazaar,* and *Vanity Fair.* He was also the official photographer for the Theatre Guild until 1927. He continued to experiment with photographic abstractions and cut-paper designs, and in 1928 exhibited his work at Der Sturm gallery in Berlin. That same year, Brugière moved to London and began a new series of light experiments. In 1930, he and Oswell Blakeston produced England's first abstract film, *Light Rhythms,* based on a series of Brugière's light abstractions. In the last years of his life, he moved to Northamptonshire to devote himself to painting.

James Enyeart, *Brugière: His Photographs and His Life.* New York: Alfred A. Knopf, 1977.

HAROLD HALLIDAY COSTAIN
(American, 1897–1994)

Harold Halliday Costain was a successful commercial photographer in the 1930s, making stylishly modernist images for a variety of clients. He did a great deal of industrial photography, creating dramatic images of subjects such as the Jack Frost sugar plant in Long Island City, New York, and the rock salt mines of Avery Island, Louisiana. He also worked as an architectural photographer, carrying out such assignments as photographing the architect Richard Neutra's first East Coast project, Windshield House on Fishers Island, New York.

JACK DELANO
(American, born in Russia, 1914–1997)

Jack Delano immigrated with his family from the Ukraine to the United States in 1923. After graduating from high school in Philadelphia, he studied drawing and painting at the Pennsylvania Academy of Fine Arts. He became interested in photography while traveling in Europe in the mid-1930s. Delano was active as a photographer for the Works Progress Administration, the United Fund, and, from 1940, the Farm Security Administration. Inspired by his experiences with the FSA in Puerto Rico, he settled there in 1946 and became the official photographer for the government of Puerto Rico. He was long active as a book illustrator, graphics consultant, music teacher, and animator.

Jack Delano. *Photographic Memories. The Autobiography of Jack Delano.* Washington, DC: Smithsonian Institution Press, 1997.

Rivera, Nelson. *Visual Artists and the Puerto Rican Performing Arts, 1950-1990: The Works of Jack and Irene Delano, Antonio Martorell, Jaime Suarez, and Oscar Mestey-Villamil.* New York: Peter Lang, 1997.

WALKER EVANS

(American, 1903–1975)

Born in St. Louis, Walker Evans studied at Williams College and at the Sorbonne in Paris. He returned from France to the United States in 1928, and within five years, though self-taught in photography, he was the subject of a solo exhibition at the Museum of Modern Art. His photographs were published in an edition of Hart Crane's *The Bridge* (1930) and in Lincoln Kirstein's journal *Hound & Horn* (1931). From 1935 to 1937, Evans worked for the Farm Security Administration, during which time he made many of the photographs that appeared in *American Photographs*, a 1938 exhibition and publication organized by the Museum of Modern Art. In 1936, Evans took a short leave from the FSA in order to photograph Alabama sharecropper families as part of a collaborative project with the writer James Agee. The results were published in 1941 as *Let Us Now Praise Famous Men*, with text by Agee and photographs by Evans. Evans's enormously influential photographs became prototypes for the American documentary movement of the 1930s and for the street photographers of the 1940s and 1950s.

Hambourg, Maria Morris, et al. *Walker Evans.* New York and Princeton: Metropolitan Museum of Art in association with Princeton University Press, 2000.

Mellow, James R. *Walker Evans.* New York: Basic Books, 1999.

T. LUX FEININGER

(American, born in Germany, b. 1910)

Born in Berlin in 1910, Theodor Lux Feininger was the son of the painter Lyonel Feininger. He made his first photographs in 1925, and the following year began studies under László Moholy-Nagy and Joseph Albers at the Dessau Bauhaus. There Feininger used his camera to document the vibrant life of the school and its pupils, as well as its celebrated modernist buildings. His early photographs reflect the influence of Russian Constructivism, as he composed images through interplays of diagonals and employed unorthodox framing. In the late 1920s, Feininger's photographs appeared in such magazines as *Das Illustrierte Blatt, Die Woche*, and *Die Dame*, and were also shown in the influential 1929 exhibition *Film und Foto* in Stuttgart. After moving to Paris in 1932, he turned his attention from photography to painting, and when he moved to New York in 1936, he abandoned most of his earlier negatives.

Büche, Wolfgang, ed., *T. Lux Feininger: Von Dessau nach Amerika: Der Weg eines Bauhäuslers.* Halle: Staatliche Galerie Moritzburg Halle, Landeskunstmuseum Sachsen-Anhalt, 1998.

WERNER DAVID FEIST

(German, 1909–1998)

Born in Augusberg, Werner Feist studied at the Dessau Bauhaus from 1927 until 1930, taking classes with Wassily Kandinsky, Paul Klee, and Josef Albers. When Feist arrived at the Bauhaus, photography was not yet a formal part of the school's curriculum, although László Moholy-Nagy encouraged its use as an experimental medium. Regular photography classes began when Walter Peterhans became a professor in 1928. Peterhans stressed the technical aspects of photography and encouraged tightly organized composition. At the Bauhaus, as Feist later put it, "Professional photography was first seen as a legitimate activity under Peterhans. But 'experiments' were not what Peterhans encouraged."

The historic 1929 *Film und Foto* exhibition in Stuttgart included Feist's photographs along with work by many Bauhaus faculty members and students. After Feist finished his studies, he moved to Prague, where he worked as a photographer and graphic designer. When German troops entered Prague in 1939, he fled to England and served in the British army until the end of the war. After the war, he was employed as an art director in London before immigrating to Montreal in 1951, where he worked as an art director and taught design.

Herzogenrath, Wulf. *Bauhausfotografie.* Stuttgart: Institut für Auslandsbeziehungen, 1983.

JAROMÍR FUNKE

(Czech, 1896–1945)

Born in Scutec, Czechoslovakia, Funke studied law and medicine at universities in Prague and Bratislava before becoming a professional photographer. In the 1920s, Funke was one of the most important Czech avant-garde photographers. In 1924, he founded the Czech Society of Photography with Josef Sudek and Adolf Schneeberger. This organization advocated avant-garde practices and attempted to combat what Funke and his colleagues viewed as the amateurish provincialism and sentimental Pictorialism of most Czech photography.

Funke worked in a variety of styles. While his work of the mid-1920s translates a version of the perceptual ambiguities of Cubism into the photographic still life, his most important work of the 1930s consists of Surrealist-inspired photographs of urban scenes. Like other Czech avant-garde photographers, Funke began doing advertising work in the late twenties. He taught advertising photography along Bauhaus-influenced lines at the State School of Graphic Art in Prague between 1935 and 1944.

Birgus, Vladimír, ed. *Czech Photographic Avant-Garde: 1918-1948.* Cambridge, MA: MIT Press, 2002.

Czechoslovakian Photography: Jaromír Funke, Jaroslav Rössler. London: Photographers' Gallery, 1985.

HUGO GELLERT
(American, 1892–1985)

Born in Budapest, Hungary, Gellert emigrated to the United States with his family in 1902. He attended Cooper Union and the National Academy of Design between 1909 and 1914. A talented illustrator and political activist on the left, Gellert published antiwar cartoons in *Elöre*, a socialist publication (1916), and contributed illustrations to *The Masses* and *The Liberator*.

Hired as a full-time illustrator for *The New Yorker* in 1925, he remained with the magazine until 1946. His cartoons were also published in *The New York World*, *New York Times* and the *Daily Worker*. Gellert was also active as a muralist, completing one of the first labor murals in the United States for the Worker's Cafeteria in Union Square in 1928. During the 1930s and World War II, he took part in a number of Popular Front organizations.

Wechsler, James. "From World War I to the Popular Front: The Art and Activism of Hugo Gellert," in *The Journal of Decorative and Propaganda Arts,* Spring 2002, 188-229.

ROSALIE GWATHMEY
(American, 1908–2001)

Born in Charlotte, N.C., Rosalie Gwathmey studied painting at the Pennsylvania Academy of Fine Arts before taking up photography in the late 1930s. After she and her husband, the painter Robert Gwathmey, moved to New York in 1942, she became a member of Photo League, studying under Paul Strand and Sid Grossman. For several years, she served on the executive committee of the Photo League and edited its newsletter, *Photo Notes*.

Gwathmey and her husband were politically active on the left, and she used her camera to call attention to the discrimination faced by working-class African-Americans in the South. When the Photo League disbanded in 1951, she gave up photography and became a textile designer. She destroyed all of her negatives and donated the majority of her photographs to the New York Public Library.

Rosalie Gwathmey: Photographs from the Forties. East Hampton, NY: Glenn Horowitz Bookseller, 1994.

RAOUL HAUSMANN
(French, born Austria, 1886–1971)

Born in Vienna, Raoul Hausmann was the son of a portrait and history painter. When he was four, the family moved to Berlin. After receiving academic training in painting and sculpture, Hausmann in 1917 began to paint in an Expressionist style, and he also began to publish polemical art criticism. In 1915 he met the artist Hannah Höch, with whom he lived until 1922. From 1918 to 1920, Hausmann and Höch were key members of the Berlin Dada group, contributing decisively to the development of Dada photomontage. In 1927 Hausmann began to make his own photographs, which were published in avant-garde magazines such as *a bis z*. When the Nazis came to power in 1933, Hausmann left Germany, and in subsequent years lived in Ibiza, Paris, Zurich, Prague, and finally Limoges. After World War II, he resumed active work in painting, photography, and photomontage, and in 1967 received his first retrospective at the Moderna Museet in Stockholm.

Der deutsche Spiesser ärgert sich. Raoul Hausmann 1886-1971. Berlin: Berlinische Galerie, 1994.

Haus, Andreas. *Raoul Hausmann: Photographies 1927-1957.* Paris: Créatis, 1979.

HENRYK HERMANOWICZ
(Polish, 1912–1992)

Henryk Hermanowicz produced his first photographs at the age of fifteen. In 1930, he apprenticed at Jan Bulhak's photography studio in Vilno, Poland, where he gained the expertise necessary to become a professional photographer and publish his first collection of works. After a 1937 move to Krzemieniec, he became a teacher of photography. The works he produced at this time are primarily architecture and landscape studies.

In 1939, Hermanowicz married Emilia Kornaszewska; the two collaborated on a book of her poems illustrated by his photographs. Hermanowicz began to study film in 1946 at the Film Institute in Kraków, where he became assistant director for folkloric films. In 1947, he joined ZPAF, the recently formed union of Polish art photographers. Over the next few years, he worked as the chief of the photo lab at the Ministry of Education in Szczytno and as a cameraman in Lódz for the Educative Films Company, where he produced at least twenty films on art and architecture.

Ziemia Zywiecka/Henryk Hermanowicz. Warsaw: Wydawn, 1982.

Fotografia Polska. New York, International Center of Photography, 1979.

LIONEL HEYMANN
(American, active 1930s–1940s)

Little biographical information has been discovered regarding Lionel Heymann, who took part in dozens of international Pictorialist exhibitions and salons during the 1930s and 1940s.

LOTTE JACOBI
(American, born in Germany, 1896–1990)

Lotte Jacobi was born in Thorn, Germany, and made her first photograph with a pinhole camera at the age of twelve. Before continuing the tradition established by her father, grandfather, and great-grandfather, all of whom were portraitists, Jacobi attended the Bavarian State Academy of Photography and the University of Munich. Her celebrated 1920s Berlin portraits of such figures as Lotte Lenya, Kurt Weill, and László Moholy-Nagy reflect the city's vibrant cultural life during this period.

In 1935 Jacobi fled Nazi Germany and opened a photographic studio in New York, which she maintained until 1955. Although Jacobi's reputation was based on the strength of her portraiture, in the 1950s she began to make landscapes as well as abstract images that she called "photogenics." In 1955 Jacobi moved to Deering, New Hampshire, where she maintained a studio and gallery from 1963 to 1970. She co-founded the photography department at the Currier Gallery of Art in Manchester, New Hampshire, in 1970.

Moriarty, Peter. *Lotte Jacobi: Photographs*. Boston: David R. Godine, 2003.

THEODOR JUNG
(American, born in Austria, 1906–1996)

Theodor (Theo) Jung was born in Vienna in 1906, and immigrated to Chicago in 1912 to join his mother. He demonstrated an early interest in photography after receiving a Brownie camera at the age of ten and photographed his surroundings throughout his years in boarding school and college. Jung also displayed skill in graphics and typography. His employment with the Federal Emergency Relief Administration in Washington, DC, where he worked as a chart draftsman, preparing statistics of unemployment, heightened his awareness of the social conditions of Depression-era America.

Shortly after meeting Roy Stryker, director of the photographic section of the Resettlement Administration, in 1934, Jung began to shoot for agricultural projects in Maryland, Indiana, and Ohio. Although Stryker admired his intuitive approach to the medium, Jung's recurring technical difficulties led to the end of his photographic assignments with the agency. After 1943, Jung focused his activities more on book illustration and design.

Auer, Anna. *Übersee Flucht und Emigration: österreichischer Fotografen*, 1920–1940 (Exodus from Austria: Emigration of Austrian Photographers 1920–1940). Vienna: Kunsthalle Wien

Interview with Theodor Jung by Richard K. Doud, January 19, 1965, Archives of American Art, Smithsonian Institution, Washington, D.C.

JÓZEF ANTONI KUCZYŃSKI
(Polish, 1877–1952)

Józef Kuczyński was born in Krakow, Poland. In 1893 he apprenticed at the portrait studio of Juliusz Mien and Józef Sebald, two of Krakow's most prominent photographers. In 1899, Kuczyński left Poland to work in studios across Europe, returning to Krakow in 1906 to open his own studio.

Kuczyński became a successful portrait photographer utilizing a soft-focus Pictorialist style. His photographs were exhibited in Pictorialist salons in Poland and abroad, making him one of the most prominent Polish photographers of his time. He joined the Polish Photo Club, an artistic organization bringing together Poland's leading photographers, upon its founding in 1930. During World War II Kuczyński closed his studio. A large collection of his work is held by the Jagiellonian University in Krakow.

DOROTHEA LANGE
(American, 1895–1965)

Born in Hoboken, New Jersey, Dorothea Lange was training as a teacher in 1913 when she decided to become a professional photographer. She worked at the studio of the Pictorialist photographer Arnold Genthe in 1914 and studied at the Clarence H. White School in 1917. Upon completing the White School course, she moved to San Francisco and opened a portrait studio, which she operated from 1919 to 1940. In 1929 at the onset of the Great Depression, she began to photograph in a documentary vein, making regular excursions with her camera through San Francisco's streets. Her photographs caught the attention of Paul Taylor, an economist at Berkley; they married in 1935 and collaborated on the book *An American Exodus* in 1939.

Between 1935 and 1939, Lange photographed extensively for the Farm Security Administration, and during this period made many of her best-known photographs. In 1941 Lange received the first Guggenheim Fellowship awarded to a woman. In 1954 she joined the staff of *LIFE* magazine, and from 1958 to 1965 worked as a freelance photographer, traveling to Asia, South America, and the Middle East. Diagnosed with terminal cancer in 1965, she devoted herself to preparing a retrospective exhibition at the Museum of Modern Art, held posthumously in 1966. Dorothea Lange is one of the nation's greatest documentary photographers. Her respectful empathy for people and her keen ability to communicate the essential elements of the situations she photographed endow her work with unforgettable power. Although best know for her FSA photographs, she produced other work, including he images of home and family life published in *American Country Woman* (1964). –LH

Meltzer, Milton. *Dorothea Lange: A Photographer's Life.* Syracuse: Syracuse University Press, 2000.

Ohrn, Karin Becker. *Dorothea Lange and the Documentary Tradition.* Baton Rouge: Louisiana State University Press, 1980.

NIELS LAUGESEN

(Danish, active 1920s–1930s)

Little is known of Niels Laugesen, a professional photographer who was active in Denmark in the 1920s and 1930s.

RUSSELL LEE

(American, 1903–1986)

Russell Lee was born in Ottawa, Illinois, in 1903, and did not take up photography until his thirties, after studying chemical engineering. After joining the photographic section of the Farm Security Association in fall 1936, Lee began to travel frequently and photograph rural and urban communities in the Midwest and Southwest, such as Pie Town, New Mexico, and San Augustine, Texas. The FSA's longest employed and most productive photographer, he worked diligently for the agency until its closure in 1942. After the war he photographed coal miners for the Department of the Interior and the oil industry for Standard Oil. Following a 1965 retrospective exhibition at the University of Austin, Texas, Lee took a teaching position at the university, where he remained until his retirement in 1973.

Brannan, Beverly, and Carl Fleischhauer. *Documenting America, 1935-1943.* Los Angeles: University of California Press, 1988.

Hurley, F. Jack. *Russell Lee, Photographer.* New York: Morgan and Morgan, 1978.

HARRY BEDFORD LEMERE

(British, 1864–1944)

Harry Bedford Lemere was born into a London family that owned a photographic business. Lemere inherited the firm, which specialized in exceptionally detailed large-format photographs of new buildings and architectural interiors. Lemere carefully planned each composition, repositioning furniture and even people as he saw fit. At the peak of his career, he produced a thousand photographs a year. Bedford Lemere & Co. remained one of Britain's leading purveyors of commercial and industrial images throughout Lemere's life.

Cooper, Nicholas. *The Opulent Eye. Late Victorian and Edwardian Taste in Interior Design.* London: The Architectural Press Ltd., 1976.

Elwall, Robert. *Building with Light: The International History of Architectural Photography.* London, Merrell, 2004.

HERBERT LIST

(German, 1903–1975)

Born in Hamburg, Germany, Herbert List studied art history at Heidelberg University between 1921 and 1923. In 1924, he returned to Hamburg to join his father's import company, and traveled on its behalf to Latin America and the United States. List was introduced to photography in 1930 by the young photographer Andreas Feininger. List quickly decided to embark on a career as a professional photographer.

From the mid-1930s, List worked primarily in London and Paris, making photographs that appeared in the pages of *Vogue, Harper's Bazaar, Verve,* and *Arts et Métiers Graphiques.* In 1937, a solo show at the Galerie du Chasseur d'Images in Paris brought wide attention to his photographs, which revealed a strong awareness of Cubist and Surrealist art as well as Italian Metaphysical painting. After World War II, List settled in Munich and worked as an associate member of Magnum Photos. He was known for widely published portraits of artists and celebrities such as Georges Braque, Jean Cocteau, and Marlene Dietrich.

Max Scheler, ed. *Herbert List: The Monograph.* Munich: Schirmer/ Mosel, 2000.

MAN RAY

(American, 1890–1976)

Man Ray, the pioneering photographer, painter, and filmmaker, was born Emmanuel Radnitsky, the son of Russian immigrants, in Philadelphia. He came to photography via painting in 1915: while preparing for the first solo show of his paintings, he bought his own camera to take photographs of his work for dealers and friends. As a young man he was a prominent figure in New York's avant-garde circles, becoming a regular at Stieglitz's 291 gallery as well as the Arensberg salon.

In 1921, Man Ray moved to Paris, where he remained for most of the rest of his life. In 1922, he began making imaginative photograms–or "rayographs," as he called them–which were initially published in a portfolio called *Les Champs délicieux,* with an introduction by Dadaist Tristan Tzara. During the 1920s and '30s, Man Ray was both an influential member of the Surrealist group and a well-known portraitist and fashion photographer. He also made a number of important avant-garde films, including *Le Retour à la raison* (1923) and *Emak Bakia* (1926).

De l'Ecotais, Emmanuelle. *Man Ray: Rayographies.* Paris: L. Scheer, 2002.

Foresta, Merry, et al. *Perpetual Motif: The Art of Man Ray.* Washington, DC: National Museum of American Art, Smithsonian Institution; New York: Abbeville Press, 1988.

GORDON PARKS

(American, b. 1912)

Gordon Parks moved from his native Fort Scott, Kansas, to Minneapolis, in 1928. He became a photographer in 1937, after seeing examples of Farm Security Administration photographs reproduced in a magazine. He worked as a fashion photographer in Minneapolis and Chicago before going to Washington, DC, in 1941 to join the FSA photographic section. He subsequently photographed for the Office of War Information and Standard Oil Company of New Jersey.

Beginning in 1944, Parks worked as a fashion photographer at *Vogue*, and when *Life* hired him as a staff photographer in 1948, he took on assignments in both fashion and photojournalism. He remained at *Life* until 1970, producing many of his most important photo essays, such as those on Harlem gangs, segregation in the South, and his own experiences with racism. Parks's many books include *Camera Portraits* (1943), *A Choice of Weapons* (1966), *Born Black* (1971), *Moments Without Proper Names* (1975), and *Half Past Autumn: A Retrospective* (1997). Solo exhibitions of his work have been held at Art Institute of Chicago, the International Center of Photography (ICP), and the Corcoran Gallery of Art.

Parks, Gordon. *Half Past Autumn: A Retrospective. Gordon Parks.* Essay by Philip Brookman. Boston and Washington, DC: Bulfinch Press, in association with the Corcoran Gallery of Art, 1997.

Parks, Gordon. *Voices in the Mirror: An Autobiography.* New York: Doubleday, 1990.

PERE CATALÀ PIC

(Spanish, 1889–1971)

Pere Català Pic, a prominent Catalonian photographer during the 1930s, spent his entire professional life in Barcelona. He worked in a Pictorialist style, which was dominant in Spain much longer than in France or Germany, until he encountered modernist photography in Paris in the 1920s. His admiration for the work of Man Ray, Maurice Tabard, and László Moholy-Nagy led to his own experiments with the possibilities of darkroom manipulation and photomontage.

From the early 1930s until the outbreak of the Spanish Civil War in 1936, Català was one of the leading figures in Spanish photography. He produced inventive advertising photography and wrote about the potential of avant-garde photography in advertising. When the Spanish Civil War broke out, Català turned from commercial to political work, designing striking posters and postcards to rally support for the Spanish Republic. After the defeat of Republican forces by Franco's right-wing army, Català remained in Barcelona and continued working in advertising and industrial photography, but the repressive political climate put a stop to the artistic experimentation that had supported the rise of photographic modernism. Català's work, forgotten during the decades of the right-wing regime, was rediscovered by Spanish photographers and art historians in the 1980s.

Idas y Caos: Trends in Spanish Photography 1920-1945. New York: International Center of Photography, 1987.

Les avantguardes fotogràfiques a espanya, 1925-1945. Barcelona: Centre Cultural de la Fundació "la Caixa," 1997.

WYNN RICHARDS (MARTHA WYNN)

(American, 1888–1960)

Born Martha Wynn, the photographer Wynn Richards used both her maiden and married surnames professionally. Raised in Greenville, Mississippi, she moved to New York in 1918 to attend the recently founded Clarence H. White School of Photography. She took White's thirty-week course and went on to a distinguished career in advertising and fashion photography. After photographing for *Vogue* in 1923, Richards and Bettie Frear, another White School alumna, worked together in advertising photography in Chicago. In 1928, Richards returned to New York, where she worked as an advertising and fashion photographer until she moved back to Mississippi in 1948.

Pictorialism into Modernism: The Clarence H. White School of Photography. Edited by Marianne Fulton, essays by Bonnie Yochelson and Kathleen A. Erwin. New York: Rizzoli, 1996.

Yochelson, Bonnie. *Wynn Richards.* New York: Photofind Gallery, 1989.

WERNER ROHDE

(German, 1906–1990)

The son of a German stained-glass painter, Werner Rohde began his training as an artist in 1925 at the Burg Giebichenstein art academy in Halle. Self-taught as a photographer, he started his first photographic project in 1927, documenting the school. Rohde made his first photographic portraits in 1929. These photographs of his future wife, Renata Bracksieck, evidence a Surrealist sensibility in their use of masks and disguise.

Rohde first exhibited in 1929 at the famous *Film und Foto* exhibition in Stuttgart. He subsequently traveled to Paris, where he spent his time studying the paintings of the old masters and

taking photographs. He worked in Germany as a freelance photographer and painter, until the advent of the Third Reich led him to stop exhibiting his photographs. After World War II, Rohde and his wife joined the Worpswede artistic colony, where he was active as a painter and worked frequently with his father.

Werner Rohde: Fotografien 1925-37. Berlin: Dirk Nishen, 1992.

JAROSLAV RÖSSLER
(Czech, 1902–1990)

Born in Smilov, Czechoslovakia, Jaroslav Rössler trained as a photographer at the studio of Frantisek Drtikol in Prague from 1917 to 1920. Rössler produced his most innovative work between 1919 and 1935. As early as 1923, he photographed light patterns and created compositions with simple objects, using backgrounds of white and black cardboard cut into expressive geometric shapes to create varying shadow effects. In 1925, Rössler was the first Czech artist to create photograms, images produced by placing objects on photosensitive paper and then exposing it to light.

From 1927 to 1935, Rössler lived in Paris, working initially for the commercial studio of Lucien Lorelle and becoming an early specialist in the Carbro process of color photography. After his arrest in Paris for photographing a street demonstration, Rössler returned to Prague and opened his own small studio, where he was active until the late 1950s.

Birgus, Vladimír, and Jan Mlčoch, eds., *Jaroslav Rössler: Czech Avant-garde Photographer.* Cambridge, MA: MIT Press, 2004.

ARTHUR ROTHSTEIN
(American, 1915–1985)

Born in New York City in 1915, Arthur Rothstein showed an early interest in photography. While studying at Columbia University, he met economics instructor Roy Stryker, who would later establish the photographic section of the Resettlement Administration (later the Farm Security Administration) in Washington, DC. Appreciating Rothstein's technical proficiency and enthusiasm for photography, Stryker hired him in 1935 as the first staff photographer for the FSA. Praised for the directness and immediacy of his imagery, Rothstein produced notable photographic series on farming communities in the Midwestern Dust Bowl. After leaving the FSA in 1940, Rothstein took a position as photographer for *Look* magazine; he remained there until 1971, ultimately serving as the magazine's director of photography.

Brannan, Beverly, and Carl Fleischhauer. *Documenting America, 1935-1943.* Los Angeles: University of California Press, 1988.

The Depression Years as Photographed by Arthur Rothstein. New York: Dover Publications, 1978.

KURT SCHWITTERS
(German, 1887–1948)

Born in Hannover, Germany, Kurt Schwitters attended the Dresden Academy of Art from 1909 to 1914. In the years after World War I, Schwitters met members of the Zurich and Berlin Dada groups and began to create collages and relief paintings assembled from found objects. He called his own approach "Merz," an invented name that he used to refer to his experimental sound poetry as well as his visual works. In the early 1920s, Schwitters was markedly influenced by his encounters with Constructivist artists such as El Lissitzky and De Stijl artists such as Theo van Doesburg. Schwitters fled Nazi Germany in 1937, settling first in Norway and then in England, where he lived until his death.

Dietrich, Dorothea. *The Collages of Kurt Schwitters: Tradition and Innovation.* Cambridge and New York: Cambridge University Press, 1993.

Orchard, Karin, and Isabel Schulz. *Kurt Schwitters, Catalogue Raisonné.* Ostfildern-Ruit: Hatje Cantz; New York: D.A.P., 2000.

BEN SHAHN
(American, born in Lithuania, 1898–1969)

Ben Shahn was born in Kovno, Lithuania, and immigrated with his family to New York at the age of six. He first worked as an apprentice to a commercial lithographer, acquiring skills that would later support him financially while he pursued his ambition to be a painter. Shahn's initial interest in photography stemmed from his use of the medium as a reference tool for his paintings.

In the 1930s, Shahn was employed as an artist at the Resettlement Administration in Washington, DC, where from 1935 to 1938 he also worked in a part-time position in Roy Stryker's photography department. Shahn exploited the portability of the 35mm camera to capture his subjects in an informal and spontaneous manner; he used a Leica with a right-angle viewfinder that enabled him to photograph subjects without their knowledge. In addition to his photographic work for the FSA, Shahn established a reputation as a leading American realist painter. A retrospective exhibition of his work was held at the Museum of Modern Art in 1947, and he represented the United States at the Venice Biennale in 1954.

Edwards, Susan. *Ben Shahn and the Task of Photography in Thirties America.* New York: Hunter College, 1995.

Kao, Deborah Martin, Laura Katzman, and Jenna Webster. *Ben Shahn's New York: The Photography of Modern Times.* Cambridge, MA: Fogg Art Museum, Harvard University Art Museums, 2000.

CARL STRÜWE

(German, 1898–1988)

Born and raised in Bielefeld, Germany, Strüwe was a self-taught photographer who became familiar with the medium through his work as a graphic designer. In 1926, he began what became a lifelong fascination with the microscopic photography of plant forms. He visited scientific laboratories to look through their slides, searching for striking images, which guided him in his selection of subjects. He regarded his own photographs as artworks rather than as scientific documents. The titles he chose for his images (*White Floating over Gray, Rhythmic Contours*) draw attention to the formal characteristics of these microscopic views. Strüwe's work became well known only after World War II. In the early 1950s, he was adopted by the "Subjective Photography" group and was included in their exhibitions. His greatest success came in 1955 with the publication of a selection of his work in the book *Formen des Mikrokosmos* (Forms of the Microcosmos).

Jäger, Gottfried, ed. *Carl Strüwe: Retrospektive Fotografie.* Düsseldorf: Edition Marzona, 1982.

Strüwe, Carl. *Formen des Mikrokosmos: Gestalt und Gestaltung einer Bilderwelt.* Munich: Prestel, 1955.

EDMUND TESKE

(American, 1911–1996)

Born in Chicago, Edmund Teske began taking photographs at age seven with his mother's Kodak Scout 2-C camera. In 1931, while attending evening classes at the Huttle Art Studio, he installed a photographic studio in his family's basement. Soon he purchased a view camera and started photographing the streets of his hometown.

After working for a commercial studio in Chicago, Teske was awarded a photographic fellowship in 1936 that enabled him to study under the guidance of the architect Frank Lloyd Wright. Teske taught in the late 1930s at Chicago's New Bauhaus (later the Institute of Design), then moved to New York to work as Berenice Abbott's assistant.

In 1943 Teske settled in Los Angeles, where he became interested in cinema, and in the early 1950s he was active with several small theater groups. During this period Teske refined the experimental photographic processes that he had begun to explore in the 1930s, such as solarization, combination printing, and chemical toning, and began to regularly exhibit and publish his work.

In the 1960s, Teske was an influential visiting professor of photography at UCLA and other schools.

Cox, Julian. *Spirit into Matter: The Photographs of Edmund Teske.* Los Angeles: J. Paul Getty Museum, 2004. *Images from Within: The Photographs of Edmund Teske.* Carmel, CA: Friends of Photography, 1980.

ELSE THALEMANN

(German, 1901–1984)

Else Thalemann was born into a well-to-do family in Berlin. She learned photography in a commercial studio, and by 1930 had set up her own studio and darkroom in her family's house. She made advertising photographs for the Berlin-based photo agency Mauritius as well as landscapes and scenes of everyday life. During this period, Thalemann became friends with Ernst Fuhrmann, a writer of books on biology, philosophy, religion, and other subjects. Fuhrmann was assembling an enormous photographic archive for what he termed his "biosophical" investigations into the structure and forms of plants, employing talented photographers such as Albert Renger-Patzsch, Lotte Jacobi, and, for a period in the thirties, Thalemann. When Fuhrmann emigrated to the United States in 1938, Thalemann effectively abandoned photography. During World War II, Allied bombs destroyed her Berlin studio, including most of her negatives.

Else Thalemann: Industrie- und Pflanzenphotographien der 20er und 30er Jahre. Berlin: Das Verborgene Museum, 1993.

Rhein, Christina. "Else Thalemann (1901-1984), Fotografin." In *Frauenmosaik: Frauenbiographien aus dem Berliner Stadtbezirk Treptow-Köpenick.* Berlin: Trafo, 2001.

WALTER TRALAU

(German, 1904–1975)

Born in Bad Segeberg, near Hamburg, Walter Tralau was a student at the Dessau Bauhaus from 1926 to 1927, taking the preliminary course with László Moholy-Nagy and Josef Albers and studying architecture with Walter Gropius. He worked as an architect and urban planner for various clients though the twenties and thirties and for the city of Cologne from 1946 to 1968.

Bauhaus: Fotografie dalla collezione della Fondazione Bauhaus di Dessau. Florence: Fratelli Alinari, 2002.

JOHN VACHON

(American, 1914–1975)

Born in St. Paul, Minnesota, John Vachon received a bachelor's degree in English literature from St. Thomas College at age twen-

ty, followed by further studies at the Catholic University of America (1935-36). After being hired as an assistant messenger with the Farm Security Administration (FSA) in 1937, Vachon quickly developed his own photographic skills. He became a member of the FSA's regular photographic staff and produced memorable documentary series in the Plains states. After moving to New York, Vachon in 1947 became a member of the Photo League, contributing numerous book reviews to the newsletter *Photo Notes* and participating in the 1948 exhibition *This Is the Photo League*. After working for many years as a staff photographer at *Look* magazine, Vachon became a visiting professor at the Minneapolis College of Art and Design in 1974.

Brannan, Beverly, and Carl Fleischhauer. *Documenting America, 1935-1943*. Los Angeles: University of California Press, 1988.

Vachon, John, and Miles Orwell. *John Vachon's America: Photographs and Letters from the Depression to World War II*. Berkeley: University of California Press, 2003.

THEO VAN DOESBURG

(Dutch, 1883–1931)

Theo van Doesburg was the pseudonym adopted by Christian Emil Marie Küpper, who was born in Utrecht, the Netherlands. After serving in the Dutch army during World War I, he settled in Leiden and gained recognition as a painter, architect, poet, and art critic. With painter Piet Mondrian and architect J.J.P. Oud, among others, Doesburg in 1917 founded the group and journal *De Stijl*, which promoted the use of elementary geometric forms in painting and architecture. Doesburg also participated in the Dada movement under the alias I.K. Bonset and briefly taught at the Weimar Bauhaus. He was instrumental in the founding of the Paris-based group Abstraction-Création just prior to his death in 1931.

Hoek, Els, et al., eds. *Theo van Doesburg: oeuvre catalogus*. Utrecht: Centraal Museum; Otterlo: Kröller-Müller Museum; Bussum: Uitgeverij Thoth, 2000.

Straaten, Evert van. *Theo van Doesburg: Constructor of the New Life*. Otterlo: Kröller-Müller Museum, 1994.

PIET ZWART

(Dutch, 1885–1977)

Piet Zwart, a Rotterdam-based designer and typographer, began his career working in the tradition of the Arts and Crafts movement, but radically reoriented his work in 1917 under the influence of the avant-garde De Stijl group. Through his De Stijl contacts, Zwart met Kurt Schwitters, El Lissitsky, and Jan Tschichold, all of whom were developing a modernist mode of graphic design, combining the technique of photomontage with geometric Constructivist elements. In the 1920s and '30s, Zwart produced advertisements in this idiom for prominent clients such as NKF (the Dutch cable works) and PTT (the Dutch postal service). He was a member of the Circle of New Advertising Designers, a group of designers founded by Schwitters, who shared similar experimental interests. In addition to his commercial design projects, Zwart was also involved in leftist politics and the Dutch worker-photography movement.

Bool, Flip. "Paul Schuitema und Piet Zwart: Die neue Typografie und die neue Fotografie im Dienst der Industrie und des politischen Kampfes." In Stanislaus von Moos and Chris Smeenk, eds., *Avant Garde und Industrie*. Delft: Delft University Press, 1983.

Lavin, Maud. "For Love, Modernism, or Money: Kurt Schwitters and the Circle of New Advertising Designers," in Lavin, *Clean New World: Culture, Politics, and Graphic Design*. Cambridge, MA: MIT Press, 2001.

EXHIBITION CHECKLIST

All works are from the Daniel Cowin Collection

Berenice Abbott
New York at Night
1934
Gelatin silver print
13 3/8 x 10 3/8 in. (33.97 x 26.35 cm)

Hans Bellmer
The Doll
1934
Gelatin silver print
4 3/8 x 3 in. (11.11 x 7.62 cm)

Hans Bellmer
The Doll
1935
Hand-colored gelatin silver print
5 1/2 x 5 1/2 in. (13.97 x 13.97 cm)

Mieczyslaw Berman
Armor for the Nation
1938/1960s
Gelatin silver print with paint
15 1/16 x 10 1/16 in.
(38.25 x 25.55 cm)

Mieczyslaw Berman
Building, II
1927/1960s
Gelatin silver print with paint and paper
applied
17 3/8 x 13 in. (44.13 x 33.02 cm)

Ilse Bing
Study for "Salut de Schiaparelli" (Lily Perfume)
1934
Gelatin silver print
19 x 15 1/4 in. (48.26 x 38.74 cm)

Brassaï
Street Scene, Paris
ca. 1930s
Gelatin silver print
8 3/4 x 11 3/4 in. (22.23 x 29.85 cm)

Francis Bruguière
Cut Paper Abstraction
ca. 1927
Gelatin silver print
9 1/4 x 7 1/4 in. (23.5 x 18.42 cm)

Harold Halliday Costain
Eel-Skid Oil
ca. 1936
Gelatin silver print
14 x 11 in. (35.56 x 27.94 cm)

Jack Delano
At the Vermont State Fair, Rutland
1941/1985
Dye transfer print (print made in 1985)
8 x 10 in. (20.32 x 25.40 cm)

Jack Delano
Mr. and Mrs. Andrew Lyman, Polish tobacco farmers near Windsor Locks, Conn.
1940
Gelatin silver print
8 x 10 in. (20.32 x 25.40 cm)

Jack Delano
Painting on a barn near Thomsonville, along Route 5, Conn.
1940
Gelatin silver print
8 x 10 in. (20.32 x 25.40 cm)

Theo van Doesburg and Kurt Schwitters
Dada Soirée
1923
Lithograph
11 7/8 x 11 3/4 in. (30.16 x 29.85 cm)

Walker Evans
Circus Poster, Alabama
1935
Gelatin silver print
7 5/8 x 9 5/8 in. (19.37 x 24.45 cm)

Walker Evans
Coca-Cola Shack in Alabama
1935
Gelatin silver print
8 x 10 in. (20.32 x 25.40 cm)

Walker Evans
Minstrel Poster in Demopolis, Alabama
1936
Gelatin silver print
7 5/8 x 9 3/4 in. (19.37 x 24.77 cm)

T. Lux Feininger
New York
1948
Gelatin silver print
10 x 8 1/8 in. (25.40 x 20.64 cm)

Werner David Feist
Water Tap on Bauhaus Wall, Dessau
1929
Gelatin silver print
7 1/8 x 5 3/4 in. (18.10 x 14.61 cm)

Jaromír Funke
Vera Violetta Perfume
ca. 1930s
Gelatin silver print
11 5/8 x 9 1/4 in. (29.53 x 23.50 cm)

Hugo Gellert
Cannons or Tractors [maquette for Workers Film and Photo League poster]
1931
Collage
17 1/2 x 11 1/2 in. (20.32 x 25.40 cm)

Rosalie Gwathmey
Charlotte, North Carolina
1944
Gelatin silver print
7 1/2 x 9 5/16 in. (18.42 x 23.81 cm)

Rosalie Gwathmey
Paris, France [woman walking by wall of posters]
1949
Gelatin silver print
7 1/4 x 9 3/8 in. (18.42 x 23.81 cm)

Raoul Hausmann
Untitled [from the "Shadows" series]
1931
Gelatin silver print
7 3/4 x 11 3/4 in. (19.69 x 29.85 cm)

Henryk Hermanowicz
Woman with Closed Eyes
1937
Gelatin silver print
11 3/4 x 9 3/8 in. (29.85 x 23.81 cm)

Lionel Heymann
The Shell [bandstand]
ca. 1930s
Platinum print
13 1/2 x 10 1/2 in. (34.29 x 26.67 cm)

Lotte Jacobi
Russian Workers
1932-33
Gelatin silver print
14 x 19 1/2 in. (35.56 x 49.53 cm)

Theodor Jung
Garrett County, Maryland. Interior of a house
1935
Gelatin silver print
8 x 10 in. (20.32 x 25.40 cm)

Theodor Jung
Interior of rehabilitation client's house, Ohio
1936
Gelatin silver print
8 x 10 in. (20.32 x 25.40 cm)

Jósef Antoni Kuczyński
Still life [pitcher and fruit]
1925
Platinum print
8 5/8 x 11 in. (21.91 x 27.94 cm)

Jósef Antoni Kuczyński
Untitled [portrait of a man]
ca. 1920s
Gum-bichromate print
11 3/4 x 8 1/2 in. (29.85 x 21.59 cm)

Dorothea Lange
Abandoned tenant house. Hall County, Texas
1937
Gelatin silver print
8 x 10 in. (20.32 x 25.40 cm)

Dorothea Lange
Hoe culture. Tenant farmer near Anniston, Alabama
1936
Gelatin silver print
8 x 10 in. (20.32 x 25.40 cm)

Niels Laugesen
Automobile [Humber Auto]
ca. 1930
Gelatin silver print
9 1/8 x 6 11/16 in. (23.18 x 16.99 cm)

Russell Lee
Mother of John Lynch, farmer, Williams County, North Dakota. She was one of the earliest homesteaders
1937
Gelatin silver print
8 x 10 in. (20.32 x 25.40 cm)

Harry Bedford Lemere
Primrose Roadworks, Liverpool, a Cunard shell-works from 1914-18
1914-18
Gelatin silver print
11 3/8 x 9 3/8 in. (28.89 x 23.81 cm)

Harry Bedford Lemere
Primrose Roadworks, Liverpool, a Cunard shell-works from 1914-18
1914-18
Gelatin silver print
11 3/8 x 9 3/8 in. (28.89 x 23.81 cm)

Harry Bedford Lemere
Primrose Roadworks, Liverpool, a Cunard shell-works from 1914-18
1914-18
Gelatin silver print
11 3/8 x 9 3/8 in. (28.89 x 23.81 cm)

Harry Bedford Lemere
Primrose Roadworks, Liverpool, a Cunard shell-works from 1914-18
1914-18
Gelatin silver print
11 3/8 x 9 3/8 in. (28.89 x 23.81 cm)

Harry Bedford Lemere
Primrose Roadworks, Liverpool, a Cunard shell-works from 1914-18
1914-18
Gelatin silver print
11 3/8 x 9 3/8 in. (28.89 x 23.81 cm)

Harry Bedford Lemere
Primrose Roadworks, Liverpool, a Cunard shell-works from 1914-18
1914-18
Gelatin silver print
11 3/8 x 9 3/8 in. (28.89 x 23.81 cm)

Herbert List
Plate Glass
ca. 1936
Gelatin silver print
11 x 9 1/2 in. (27.94 x 24.13 cm)

Man Ray
Empire State Building
1936
Gelatin silver print
11 1/2 x 9 in. (29.21 x 22.86 cm)

Man Ray
Untitled [Rayograph]
1924
Gelatin silver print
10 3/4 x 8 1/2 in. (27.31 x 21.59 cm)

Gordon Parks
Contents of an army supper K-Ration Unit, used by soldiers on the fighting front
1945
Gelatin silver print
7 5/8 x 9 5/8 in. (19.37 x 24.45 cm)

Gordon Parks
Gilbert & Barker. Five and ten cent store, Main Street, Springfield, Massachusetts
1945
Gelatin silver print
7 9/16 x 7 3/8 in. (19.21 x 18.73 cm)

Pere Català Pic
"Bily" Shoes
ca. 1930s
Gelatin silver print
10 15/16 x 8 in. (27.79 x 20.32 cm)

Pere Català Pic
Ovarina
ca. 1930s
Gelatin silver print
11 5/16 x 7 1/2 in. (28.73 x 19.05 cm)

Wynn Richards (Martha Wynn)
Colander and Spoons
ca. 1918
Gelatin silver print
8 1/8 x 6 1/8 in. (20.64 x 15.56 cm)

Werner Rohde
Pit and Renata
ca. 1933
Gelatin silver print
8 3/4 x 6 1/2 in. (22.23 x 16.51 cm)

Jaroslav Rössler
Untitled [double exposure of woman's face and woman in evening gown]
1933
Gelatin silver print
10 3/4 x 7 3/4 in. (27.31 x 19.69 cm)

Arthur Rothstein

Oregon or bust. Leaving South Dakota for a new start in the Pacific Northwest
1936
Gelatin silver print
8 x 10 in. (20.32 x 25.40 cm)

Ben Shahn
Housewife, Small Town, Ohio
1935–38
Gelatin silver print
8 x 10 in. (20.32 x 25.40 cm)

Carl Strüwe
Needles as Life-form of the Diatom "Synedra danica,"
1929
Gelatin silver print
9 1/16 x 6 13/16 in. (23.02 x 17.30 cm)

Carl Strüwe
Straight Lines: Crystal of Coffea Arabica
n.d.
Gelatin silver print
9 1/4 x 6 7/8 in. (23.50 x 17.46 cm)

Carl Strüwe
Structure of a Human Bone
n.d.
Gelatin silver print
15 3/4 x 11 13/16 in. (40 x 30 cm)

Edmund Teske
Mannequins, Chicago
1938
Gelatin silver print
9 11/16 x 7 7/16 in. (24.61 x 18.89 cm)

Edmund Teske
Tijuana, Mexico
ca. 1959
Gelatin silver print
7 1/16 x 4 7/8 in. (17.94 x 12.38 cm)

Else Thalemann, attr.
Machine Detail
ca. 1930
Gelatin silver print
6 5/8 x 8 3/4 in. (16.83 x 22.23 cm)

Walter Tralau
Assignment for László Moholy-Nagy's Preliminary Course at the Bauhaus
ca. 1926-27
Gelatin silver print
4 1/8 x 3 in. (10.48 x 7.62 cm)

Unidentified artist
Baseball All-Star Game
n.d.
Offset lithograph
16 1/2 x 25 3/8 in. (41.91 x 64.45 cm)

Unidentified artist
Douglas Fairbanks Film Premiere, Grauman's Chinese Theater, Hollywood
1928-29
Gelatin silver print
7 x 9 in. (17.78 x 22.86 cm)

John Vachon
FSA trailer camp for defense workers
1941
Gelatin silver print
8 x 10 in. (20.32 x 25.40 cm)

John Vachon
Girl on Lobster
1938
Gelatin silver print
7 7/16 x 9 5/8 in. (18.89 x 24.45 cm)

John Vachon
Riding out to bring back the cattle. First stages of snow blizzard, Lyman County, South Dakota
1940
Gelatin silver print
8 x 10 in. (20.32 x 25.40 cm)

John Vachon
Washing up for dinner on Pat McRaith's farm, Meeker Co., Minnesota
1942
Gelatin silver print
8 x 10 in. (20.32 x 25.40 cm)

Piet Zwart
Stack of Doors
1931
Gelatin silver print
6 7/8 x 4 3/4 in. (17.46 x 12.07 cm)

SELECTED BIBLIOGRAPHY

Birgus, Vladimír, ed. *Czech Photographic Avant-Garde: 1918-1948.* Cambridge, MA: MIT Press, 2002.

Clair, Jean, ed. *The 1920s: Age of the Metropolis.* Exhibition catalogue. Montreal: Montreal Museum of Fine Arts, 1991.

Coke, Van Deren, and Diana Dupont. *Photography: A Facet of Modernism. Photographs from the San Francisco Museum of Modern Art Collection.* Exhibition catalogue. New York: Hudson Hills Press, in association with the San Francisco Museum of Modern Art, 1986.

Fotografia Polska. Essay by William A. Ewing. Exhibition catalogue. New York: International Center of Photography, 1979.

Fulton, Marianne, ed., with texts by Bonnie Yochelson and Kathleen A. Erwin. *Pictorialism into Modernism: The Clarence H. White School of Photography.* New York: Rizzoli, 1996.

Hambourg, Maria Morris, and Christopher Phillips. *The New Vision: Photography between the World Wars.* Exhibition catalogue. New York: Metropolitan Museum of Art, 1989.

Hight, Eleanor M. *Picturing Modernism: Moholy-Nagy and Photography in Weimar Germany.* Cambridge, MA: MIT Press, 1995.

Hurley, F. Jack. *Portrait of a Decade; Roy Stryker and the Development of Documentary Photography in the Thirties.* Baton Rouge: Louisiana State University Press, 1972.

Idas y Chaos: Trends in Spanish Photography 1920-1945. Exhibition catalogue. New York: International Center of Photography, 1985.

Images from the Machine Age: Selections from the Daniel Cowin Collection. Essay by Ellen Handy. Exhibition catalogue. New York: International Center of Photography, 1997.

Krauss, Rosalind, and Dawn Ades. *L'Amour fou: Photography and Surrealism.* New York: Abbeville, 1985.

O'Neal, Hank. *A Vision Shared: A Classic Portrait of America and Its People, 1935-1943.* New York: St. Martin's Press, 1976.

Phillips, Christopher, ed. *Photography in the Modern Era: European Documents and Critical Writings, 1913-1940.* Exhibition catalogue. New York: Metropolitan Museum of Art, 1989.

Pultz, John, and Catherine B. Scallen. *Cubism and American Photography, 1910-1930.* Exhibition catalogue. Williamstown, MA: Sterling and Francine Clark Art Institute, 1981.

Rothschild, Deborah, Ellen Lupton, and Darra Goldstein. *Graphic Design in the Mechanical Age: Selections from the Merrill C. Berman Collection.* Exhibition catalogue. New Haven: Yale University Press, in conjunction with Williams College Museum of Art and the Cooper-Hewitt National Design Museum, Smithsonian Institution, 1998.

Sobieszek, Robert A. *The Art of Persuasion: A History of Advertising Photography.* New York: Abrams, 1988.

Stange, Maren. *Symbols of Ideal Life: Social Documentary Photography in America, 1890-1950.* Cambridge: Cambridge University Press, 1989.

Teitelbaum, Matthew, ed. *Montage and Modern Life, 1919-1942.* Exhibition catalogue. Cambridge, MA: MIT Press, 1992.

Trachtenberg, Alan. *Reading American Photographs: Images as History, Mathew Brady to Walker Evans.* New York: Hill and Wang, 1989.

Travis, David. *Photography Rediscovered: American Photographs, 1900-1930.* Exhibition catalogue. New York: Whitney Museum of American Art, 1979.